Julian Schnabel

Works on Paper 1975-1988

Julian Schnabel

Works on Paper
1975-1988

Edited by Jörg Zutter

With essays
by Brooks Adams, Donald Kuspit,
and Jörg Zutter

Prestel

This book was published in conjunction with the exhibition
held at The Fruitmarket Gallery, Edinburgh (May 26-July 1, 1990) and
the Museum of Contemporary Art, Chicago (July 14-September 30, 1990).

First published in German in conjunction with
the exhibition 'Julian Schnabel, Arbeiten auf Papier 1975-1988'
shown at the Museum für Gegenwartskunst Basel
(May 21-July 17, 1989) and at the Staatliche Graphische Sammlung München
at the Neue Pinakothek, Munich (February 7-April 1, 1990)

Cover illustration: *Die Elbe*, 1985 (Cat. 47, detail)

Translation of the essay by Jörg Zutter from the German
by Dorothy M. Kosinski

Published by
Prestel-Verlag, Mandlstrasse 26, D-8000 Munich 40, Federal Republic of Germany
Tel. (89) 38 17 09 0, Telefax (89) 38 17 09 35

Distributed in continental Europe and Japan by Prestel-Verlag,
Verlegerdienst München GmbH & Co KG,
Gutenbergstrasse 1, D-8031 Gilching, Federal Republic of Germany
Tel. (81 05) 21 10, Telefax (81 05) 55 20

Distributed in the USA and Canada by te Neues Publishing Company, 15 East 76th Street,
New York, NY 10021, USA
Tel. (212) 288 0265, Telefax (212) 570 2373

Distributed in the United Kingdom, Ireland and all other countries
by Thames & Hudson Limited, 30-34 Bloomsbury Street, London WC 1 B 3QP, England
Tel. (1) 636 5488, Telefax (1) 636 4799

Deutsche Bibliothek Cataloguing-in-Publication Data
Julian Schnabel: Works on Paper; 1975−1988;
[in conjunction with the exhibition
held at the Fruitmarket Gallery, Edinburgh (May 26 − July 1, 1990)
and the Museum of Contemporary Art, Chicago (July 14 − September 30, 1990)]/
ed. by Jörg Zutter. With essays by Brooks Adams ...
München: Prestel, 1990

Design: Dietmar Rautner
Composition: Fertigsatz GmbH, Munich
Color separations: GEWA-Repro Gerlinger und Wagner GmbH, Munich
Printing and binding: Passavia Druckerei GmbH, Passau

Softcover edition not available to the trade
ISBN 3-7913-1061-5 (English Edition)
ISBN 3-7913-0991-9 (German Edition)
Printed in Germany

Contents

Foreword

This publication on Julian Schnabel's works on paper dating from 1975 to 1988 is an attempt to highlight an aspect of the work of this American artist which has heretofore been entirely neglected. Until now, European and American museums have shown only Schnabel's paintings (with the exception of some sculptures), but never his drawings.

Julian Schnabel first gained recognition in 1978, as he restored the panel painting to a position of importance in contemporary art, combining painting with unusual materials which he nailed, glued, or screwed onto his pictures. While the painted forms, symbols, figures, and theatrical situations resist interpretation, the material itself – for example, broken plates, deer antlers, or branches – function as the carrier of meaning, while endowing the pictures with plasticity. Wood, velvet, or – as in his latest works – huge tarpaulins serve as support.

None of the things which have brought the artist the highest praise and the sharpest criticism can be found in the selections of seventy-one works on paper illustrated in this volume. The essays included here show that, in many cases, the drawings offer new possibilities for deciphering the content of Schnabel's paintings, which are concerned with a heroic feeling for life, full of longings and exaltations, anxieties and presentiments of death. The drawings also grant the possibility of interpreting the painting support, which is sometimes brittle or spotty and sometimes protrudes aggressively into space. Hence, the works on paper always lead back to the paintings and, in fact, constitute their spiritual and sensual source, thus effectively undermining those negative critiques which have denied Schnabel's work any creative basis. It would be wrong to describe the thematically grouped drawings as mere sketches or studies for the large-scale paintings of the sculptures. Rather, they offer precise insights into Schnabel's artistic starting points and, at the same time, reveal themselves to be confessions which, though noticeably reserved, exude a primal poetic force.

Neither the admirers nor the critics of Schnabel's work have attempted to come to grips with the deeper basis of his new artistic approach. Scarcely anyone has noticed that the pictures contain contradictions, that the compositions do not disintegrate amidst the animated and seemingly exploding grounds. Yet it is precisely the unstructured ground of the pictures and the resulting intense presence of his work that occasion considerations of this kind.

The individual forms or volumes which can be recognized in the drawings call to mind developing vegetal forms, as well as stiffened bodies or petrifications. At the same time, they recall the simplest of strucures and objects, such as swords, urns, mummies, insect larvae, or excavation findings. Equal in importance, life and death present themselves as the content of these drawings. In other words, the creation of a work always implies a preoccupation with death and presupposes the conquest of fear.

With Schnabel, a work of art is thus only possible if this conflict has taken place and the fear of death has yielded to a new quality of perception. The works on paper can also be understood as witnesses to a struggle with death, and make clear that, for Schnabel, a work of art always signifies a revolt against the transitoriness of being. In the words of the artist: "Agony has many faces. One need not talk of agony but it is the reason why I began to work. It is the reason why I continue to work. When I'm working I feel OK. But a need to make something isn't a need to feel better. You have a feeling about something; you're working when you're looking for it."[1] The place where the present threatens to vanish, where it is about to become the past and, therefore, history, is the place where the work of art originates. In many cases, the drawings can be read as open wounds, as visions into the interior of a living body. These seismographic records of artistic conditions clarify such moments as birth and death, and such processes as growth and decay.

While traces of these motifs can be found in many of Schnabel's paintings and sculptures, they are present in

their most pristine form in the drawings. On the fields of shards, fur supports, or tarpaulins, they become static elements, stiffened forms, solid islands in a rough sea, or stable foundations on a quaking earth. Schnabel's basic concern – to make primal forms of any sort into the starting point of a message of content – is expressed in his works on paper. It would seem that the artist tries to free these forms and structures from oblivion and to assign them to the present. He does the same with familiar symbols – for example, the Christian cross or mystical signs – as well as with citations from well-known paintings in the history of European art. His drawings also reflect the revolutionary mood which characterizes art after the transition from a phase burdened with concepts and theories to a period with a new romantic-expressive imprint.

In his paintings, Schnabel repeatedly uses motifs from his drawings. He does not simply copy these on a larger scale, but rather tries to transfer this fragile aspect of the creation of pictorial forms in a way suitable to the medium. In the drawings, the process of creation and transformation is captured precisely and becomes a theme in itself; in the paintings, this process is intensified dramatically. The drawings are personal snapshots or confessions, which recall poems or letters. The paintings on the other hand, should be understood as perceptions of a new historical reality. The drawings also reveal the processes underlying Schnabel's medium-critical working method. Like the paintings, the drawings themselves are often called into question, when, for example, the frame or the *passe-partout* expands the composition or when a new landscape appears on a map. Thus, Schnabel continues a European tradition, namely, the poly-perspectival way of seeing reality initiated by Cubism. This questioning of the nature of the images was continued in the art of the 1980s.[2]

A similar medium-critical attitude already played a part in nineteenth-century museum presentations of European painting, especially as easel painting was not presented throughout as an independent genre, but placed in a wider context. In Leo von Klenze's Alte Pinakothek in Munich, the display began, not with works from the earliest periods of European oil painting, but with Greek vases, exhibited since 1840/41 in a vaultlike room that was adorned with imitations of frescos from Etruscan tombs.[3] According to this view Western painting developed symbolically out of Greek vase painting. Schnabel moves the fictitious origin of painting and art in general directly into his paintings and drawings, with the latter often playing the role of key works that offer an insight into the deep roots of the content of the paintings.

The preparations for this publication go back to 1986. Stimulated by the question discussed above, the possibility was considered of presenting an exhibition of a large number of Julian Schnabel's works on paper, spanning his entire output. With this in mind, an inventory of such works was begun.

Julian Schnabel and his assistants have contributed a great deal to the realization of this traveling exhibition, organized by the Museum für Gegenwartskunst in Basel, and its accompanying catalogue. They deserve our heartfelt thanks. We are especially grateful to the lenders for their generosity in making their works on paper available. In addition, we would like to thank Bruno Bischofberger, Galerie Bruno Bischofberger, Zurich, and Douglas Baxter, The Pace Gallery, New York.

Jörg Zutter

NOTES

1 Julian Schnabel, "The Patients and the Doctors," *Artforum* 22, February 6, 1984, p. 55.
2 See Hennelore Kersting, "Kunst-Modelle," in exhibition catalogue, *Skulptur Projekte in Münster 1987*, ed. Klaus Bussmann and Kaspar König, Cologne, 1987, pp. 359-67.
3 Gisela Goldberg, "Ursprüngliche Ausstattung und Bilderhängung der Alten Pinakothek," in exhibition catalogue, *"Ihm, welcher der Andacht Tempel baut...": Ludwig I. und die Alte Pinakothek. Festschrift zum Jubiläumsjahr 1986*, Bayerische Staatsgemäldesammlungen, Munich, 1986, pp. 150-51.

Jörg Zutter

Between Heaven and Earth
Works on Paper by Julian Schnabel

In comparision to his large-scale paintings and his monu-mental sculptures, the works on paper by Julian Schnabel seem reserved, not only in terms of size but also in the energy invested in the media employed. Many works are puzzling precisely because of the sparing use of graphic and painterly means, which, at the same time, is the source of their strong visual impact. The early works on paper, cre-ated in 1978/79 – for example, certain pages from sketch-books, which are covered with oil stains and blotches of paint (cat. 3-8) – give the impression of having been cre-ated accidentally. The simplest forms and linear construc-tions are recorded with a few strokes. At first glance, it is often impossible to differentiate between intention and chance in these drawings. Such minimal, sketchy hints and suggestions, recall the cave paintings of prehistoric cul-tures, the creases and lines of the palm, or the course of rivers and brooks on a map. The fine lines seem to be etched into the surface of the paper, and thus physically embedded in it (cat. 6).

This bond between figure and ground must be investi-gated with regard to the content of the works. It has a for-mal counterpart in the paintings, where the composition is laid out on a surface which is similarly porous. Since 1975 the canvas in Schnabel's paintings has no longer remained a planar surface, but literally opens up in front of the view-er, moves towards him or away from him (fig. 1-3). In the pictures with plates, developed in 1978, this opening up of the surface is explored further (fig. 4-6): complete sets of dishes are spread out like a rug, consisting almost entirely of shards. In one's imagination, the related shards could be reassembled into a plate or bowl; in the reality of the pic-ture, however, they remain broken pieces lying side by side.

This gives rise to associations with the *craquelé* in the glaze of ceramics or, more generally, with an arid land-scape. The individually painted forms, signs, and figures constitute pure painterly depictions against an otherwise rugged surface. They are, nonetheless, inseparably con-nected with the surface, not only from the point of view of

medium but in content as well. The picture offers a glimpse of hidden realities. The fragmentation and concomittant reshaping of the picture surface is a prerequisite for this type of expansion of reality. The artistic creative process is comparable to the working method of an archaeologist who, in order to reach the traces of earlier cultures, has to excavate the soil layer by layer.

In drawings, artistic intentions can be visualized directly and without compromise. Schnabel has made these wide-reaching possibilities his own, by the way in which he pre-pares the ideas for later pictures on the paper and dares to use radical new approaches. The works on paper discussed here make this point of departure clear, and thus provide the basis of an understanding (lacking until now) of his painting and his sculpture, which, even today, are ap-proached with expectations of the wrong kind.[1] Moreover, the drawings reveal that Schnabel's art grows out of an attitude which encompasses the complexity of existence, as well as the impact and presence of the cultural past.

A work (cat. 5) dating from Schnabel's 1978 sojourn in Madrid exemplifies how forms, figures, and scanty lines, drawn in mere silhouette, literally disappear on the sheet amidst unnumerable color blotches and oil spots. It is strik-ing that the scribblings evoke the impression both of a plan – of an excavation, say – and of an architectural context (indicated by the hints of a rounded arch at the upper edge).

Julian Schnabel himself has said of the forms and motifs developed in his drawings since about 1979: "Now I started to make drawings of poplar trees that I had seen in Pisa. Their scale looked human next to the leaning tower that looked to me like a tree, certainly in comparison to the poplar trees that surrounded it. The poplar tree for me be-came a surrogate for the figure. It was only a conical from. If I took the stem off, it looked like a dunce cap. If I put a couple of extra curves in it, it looked like a statue. If I cut it in half, it looked like a broken torso. It was just a line. I was looking for the multiplicity of uses and impulses that can

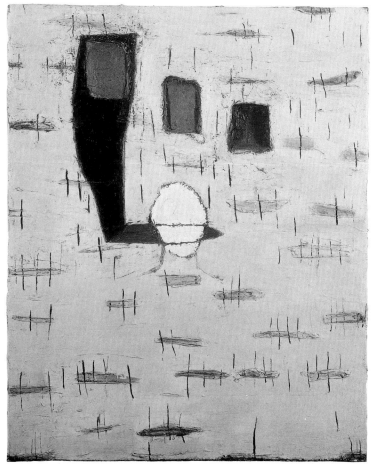

1 *Jack the Bellboy (A Season in Hell)*, 1975
Oil, emulsion paint, and pencil on canvas, 72 x 48 in. (183 x 122 cm)
Arthur and Carol Goldberg, Collection, New York

insect larva to the earthbound caterpillar, metamorphosed into a flying insect; the tuber to the growth under the earth's surface in the direction of the heavens. These various interpretations are not farfetched, but rather, are in accordance with Schnabel's universal point of departure.

On another sheet (cat. 3) is an erect, conical volume with branches or wings, in a vaguely perspectival pictorial space. It would be going too far to identify this tuberlike construction as an insect slipping out of its larva and beginning to fly. It is much more important to recognize that sculptural and painterly problems are obviously represented here simultaneously. The meeting of media that operate in different dimensions – sculpture and two-dimensional images

2 *First Italian Abstract Painting*, 1976/77
Oil on canvas, 78³/₄ x 55¹/₈ in. (200 x 140 cm)
Private Collection, courtesy of Galerie Bruno Bischofberger, Zurich

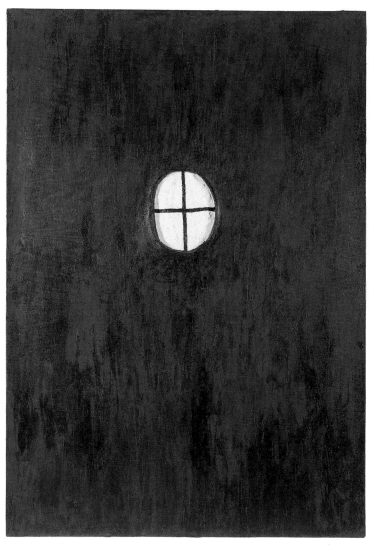

come out of one shape, in the way a poet looks for the cumulative resonance in a single word. I was also looking for a multiplicity of signals that a shape could give off, the ambiguities of different shapes."[2]

This polyvalent way of seeing is reflected in the graphic work. As early as 1978, Schnabel, inspired by a visit to the Arena Chapel in Padua, had transformed the figures in *L'incontro alla Porta Aurea* from Giotto's fresco cycle into conical volumes and forms (fig. 7), which can be related on the one hand, to two cypresses and, on the other, to a mummy wrapped in bandages (fig. 7, cf. cat. 38 and fig. 8, 9).

In another drawing from the same series (cat. 4) a wrapped mummy appears again. It could also be a root, tuber, insect larva, and many other things. The meanings are interchangeable. The mummy relates to life after death; the

8

– climaxes in the concept of wavelike surfaces as reliefs with expanded plasticity. Schnabel's theme is clearly the depiction of a volume and its transformation, a process to which the object is exposed.

The idea of opening up the surface of the picture by means of broken plates dates back to Schnabel's stay in Barcelona in 1978, during which he was very impressed by the architecture of Antoni Gaudi.[3] Shortly afterwards, back in his hotel room in Madrid, he came to other important conclusions relating to his sculptural work: one can recognize two objects in a space suggested by three lines (cat. 5). This deals with a basic problem of sculpture, namely, how it can be derived from the reduction or addition of volume. The bench owes its existence to the dividing up and carving out of a cylinder; whereas the sculpture in the foreground originated through the putting together of three different parts, whose oval borders stress their unity. The location of the sculpture in space cannot be determined because it is cut off by the lower edge of the picture. The bench stands parallel to the suggested back wall, but appears to float in relation to the floor. Both "sculptures" belong to different levels, but are nonetheless not entirely separate from one another. A narrow hexagon, hovering horizontally above the ground level and reminiscent of a piece of parkett flooring or a tile, holds both objects together like a clamp or a hinge and relates them to each other. The relationship of bench and sculpture could be explained by the fact that Schnabel had frequently designed furniture and had applied experiences gained in his sculptural work to these utilitarian articles (cf. cat. 23, 24).

Schnabel successfully evolves his own basic forms and basic volumes, which have no predetermined message, but rather acquire meaning only through their immediate context. This can be demonstrated by another drawing of a comparable interior space (cat. 8). An Ionic capital hovers freely in space next to a cypress tree. A line on the right underscores the thematic connection between the two volumes. Capitals and columns should not be understood as references to Greek architecture. They serve no structural purpose, but appear mostly as fragments (cat. 2) and only exceptionally as undamaged single pieces (cat. 9). In the latter drawing, the column is related to a railway station. It functions as a monument to the "age of iron." The two black points under the slanted beams may also represent a similar allusion, if read as the wheels of a train. The structural use of this classical architectural element in the nineteenth century is of less interest to the artist than its

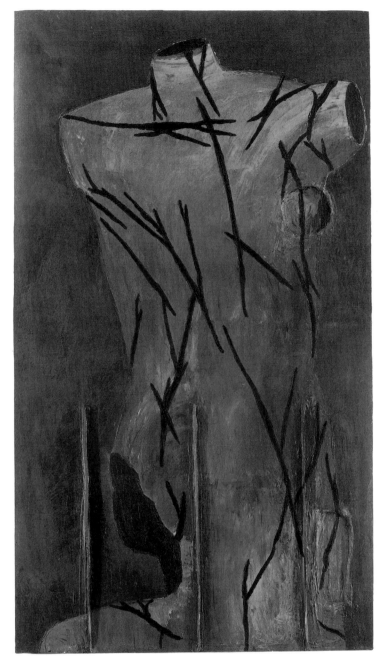

3 *St. Sebastian – Born in 1951, 1979*
Oil and wax on canvas, 111 x 66⅛ in. (282 x 168 cm)
Collection of the artist

transformation in meaning by means of the unlimited possibilities of the castiron technique.

Schnabel's art involves more than an intelligent reflection on the effects of the past on the present. It should not be understood as nostalgic longing for pure form, but rather can be explained as a declaration of belonging to our time

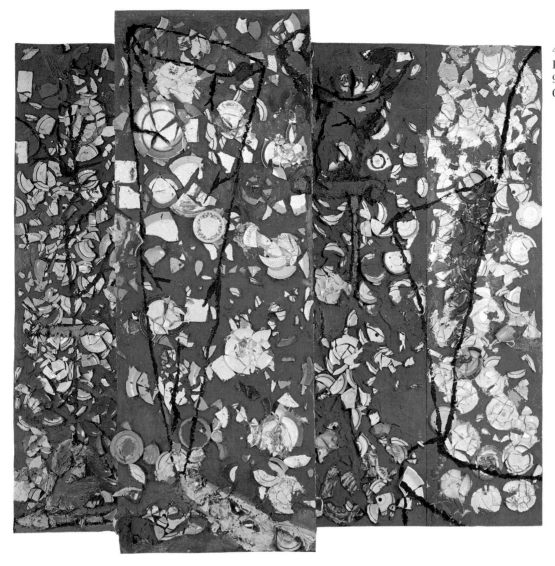

4 *The Patients and the Doctors*, 1978
Plaster, oil, plates, and tile on Masonite,
96 x 107⁷/₈ in. (244 x 274 cm)
Collection of the artist

and of the need to reestablish through artistic means the disrupted balance between culture and nature, man and his environment – more in an philosophical or aesthetic than in an ecological sense. Since the advent of the museum in the early nineteenth century, with its presentation of items of cultural and art history in terms of historical development, each collected object has become an anonymous part of a specific field of scientific investigation. In this positivistic structure the original context of the artwork and its universal significance become side issues. The transition from architecture or sculpture to anthropomorphic or organic forms acquires great importance in this context.

Untitled Drawing for Aldo Moro (cat. 12) proves to be just such a catalogue of forms and volumes, ambiguous in two ways. The brown-green form in the middle of the sheet can be associated with a plant in a pot, an urn, a spade, a bust, and many other things. The swordlike form to the right

resembles the leaf of a plant by reason of the stem attached to it. The drawing radiates a deceptive, archaic calmness, behind which something ill-defined lurks. The flesh-colored object on the block which is suggested in perspective at the upper left resembles a detached organ, out of which grows a threatening thorn. It therefore calls to mind a slaughter or a sacrificial offering. This interpretation is consistent with the title of the drawing, which indicates that it is a homage to Aldo Moro, murdered in 1978.

In Schnabel's drawings, the contours and lines, sometimes accentuated by repeated side-by-side strokes, and the fine hatching receding into the compositions form an imaginary landscape which creates an ideal base for the patches of color, nuanced in oil-crayon. The drawings can therefore also be understood as skeletons or scaffoldings on which the main accents rest. This is the impression one gains from

10

5 *Aborigine Painting*, 1980
Oil, plates, wood, and canvas,
96 x 83⅞ in. (244 x 213 cm)
Jacqueline Schnabel Collection, New York

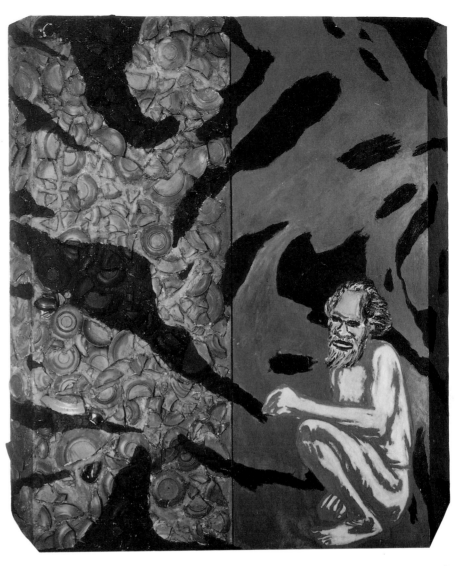

Drawing for Albrecht Dürer (cat. 14). A pointed form in the middle of the composition appears to be the key to the drawing. It can be read as a mummy stood on its head, a dagger, a tree (cf. cat. 6), or the outline of a nose. In the latter case, there is a similarity to the flattened head of a Cycladic idol, articulated only by a pronounced nose. The dark brown form at the top gives rise to different associations. It resembles an anvil or the bottom of a clay jar. What is especially striking is how the earth-colored form stands out against the poetically textured, sky-blue blackground. This explains the allusion to Dürer in the title, echoing as it does Dürer's landscape watercolors and his still lifes from nature.

Schnabel's relationship to the great master of the German Renaissance becomes more concrete in the drawing entitled *Joan of Arc* (cat. 13). The left-hand section of the work can be identified as a transformation of *Nosegay of Violets* (fig. 10), a watercolor formerly attributed to Dürer.[4] To the right of this green-violet flower still life Schnabel places a volume, a mummy or an urn, which originally had a rectangular base, but which has been expanded into a broader pedestal with a prominent orange-colored heart shape (cf. fig. 8, 9). The marked broadening of the contours in the lower part of the light grey volume is especially striking, and creates a strong connection with the heart form. This conglomeration of anthropomorphic and vegetal volumes in the right-hand section of the drawing corresponds to the nosegay of violets on the left, whose leaves and blossoms combine to form a single entity: a reinterpreted still life that points not only to the transitory nature of life, as in the lavish works from the great period of still life painting, but also to its metamorphosis and expansion.

A surprising number of drawings from 1979 establish a correspondence between particular forms and volumes as a

result of deliberate calculation (cf. cat. 17, 23). They often give the impression of being picture puzzles. In *Second Drawing for Aldo Moro* (cat. 17), the statue in the middle, drawn in outline; the branch below, which sprouts out of the felled tree; and the poplar to the extreme right, all seem to point to the problem of the separation of content from form. The larvalike form at the left welds all the components into a unity: the black tip and the cross on the scrap of transparent paper can be related to the death of Aldo Moro, to whom the drawing is dedicated.

One drawing (cat. 22), striking because of its clear composition, can be interpreted as a homage to Schnabel's treasured friends, Blinky Palermo and Imi Knoebel, artists who, in the 1970s, laid the groundwork for a new abstract painting in West Germany. The drawing indicates a recognition of these European artists at a date that is surprisingly early for an artist of Schnabel's American background. The rectangular form, bounded on two sides by red bars, reveals a portion of a bandage and calls to mind Schnabel's drawing of a wrapped mummy (cat. 4). The white modeling paste, applied in thick relief; the fine pencil lines indicating the bandage; and the strongly contrasting blood-red beams awaken associations with a wounded body. This impression is reinforced by the form on the right, which recalls a sword or an idol. The rectangular area thus becomes a symbol of the body's vulnerability and, in a metaphorical sense, of the artist laying himself bare during his work. That the form in profile on the right can also be related to the artistic creative process becomes clear if it is read as a baker's pastry bag. The fact that Schnabel has provided this instrument with two different tips brings to mind its manysided uses and, transposed to the level of artistic activity, relates to notions of continual variation and innovation.

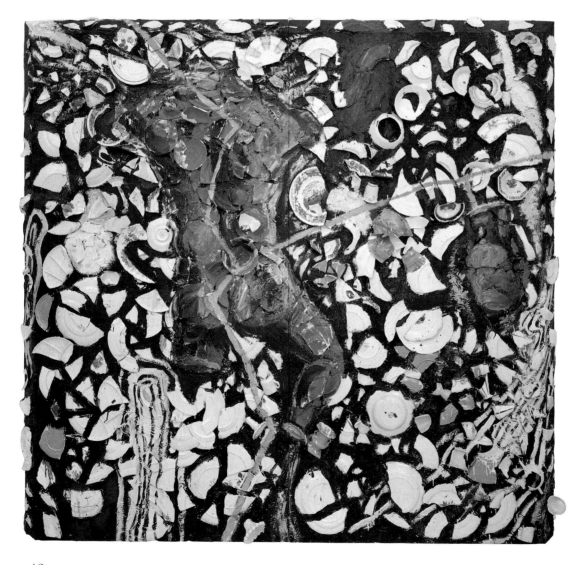

6 *What to Do with a Corner in Madrid (Part Two)*, 1980
Oil and plates on wood,
89⁵/₄ x 96 in. (228.6 x 243.8 cm)
Private Collection, courtesy of
The Pace Gallery, New York

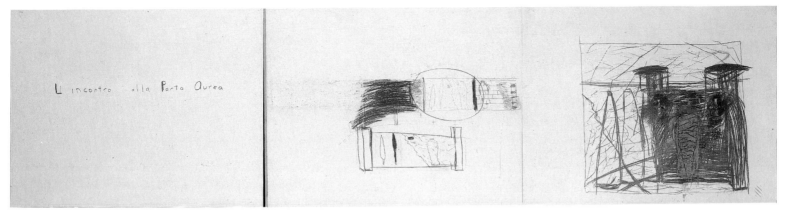

7 *L'incontro alla Porta Aurea*, 1978 (Cat. 72)

In his drawings, Schnabel likes to indicate the complexity of reality as he experiences it at a particular moment. Many works reflect an unending back-and-forth between his inner world and the outside world, as he experiences it anew each day. For Schnabel, the medium of drawing is, to a certain extent, only a tool, a possibility of giving diagrammatic expression to this oscillation and of making it apparent to the viewer. The piece of paper is essentially an intermediate station in the development of, or a transfer point for, artistic ideas. The frame, the borderline between art and reality, can assume an important function in this respect and relativize the significance of the drawing.

In the middle of a drawing with an arrangement of black patches (cat. 21) is a color reproduction of the head of the Delphic Sibyl from Michelangelo's frescos in the Sixtine Chapel in Rome. At first glance, the black patches, which constitute the actual drawing, seem relegated to a *passe-partout* and the pasted-on color reproduction would seem to take over the function of artwork. On the other hand, the head could have been formed out of the underlying spots, or, conversely, the spots could be interpreted as fantastic mutations of the head or as magic forms relating to the oracle of the Sibyl. The fact that the entire sheet is bounded by a frame of brown-white spotted cow or ponyhide raises further questions. In which realm does the authentic artwork lie? Does not the hide – that is, the skin of an animal – possess greater artistic intensity than the black spots, formally derived from it?

In the painting *Prehistory: Glory, Honor, Privilege and Poverty* (fig. 11) of 1981, the heads and figures actually seem to derive from the black spots of the ponyhide which is used as the picture's ground. In creating such a set of references, Schnabel undoubtedly questions his own artistic achievement. In other words, the reference to content in a work of art, which is open and not reduced to a firmly circumscribed field, is of essential importance to him. The use of hide as frame or ground – and the related use of antlers (cf. fig. 12) – must be understood against this background and not as the result of an inclination towards the kind of theatrical ostentation favored by such nineteenth-century "painter-aristocrats" as Hans Makart in Vienna or Franz Lenbach in Munich.[5]

In the work mentioned above (cat. 21) Schnabel breaks with the traditional hierarchy of frame, *passe-partout*, and drawing. Their status in this work cannot be exactly pinned down: their priority changes in both an inward and an outward direction. This game is augmented by the fact that the framing of hide is surrounded by a wood frame and is thus itself transformed into a *passe-partout*.

Dead Drawing (cat. 28) represents the climax of these hide-framed drawings. Here, the calling into question of different pictorial areas is pushed to an explosive extreme. The composition is symmetrically organized on the sheet of paper. In the lower part of the work, one sees a dark brown rectangle with a T-form atop it. A square, outlined above in pencil, is the frame of the main subject: antlers, a strip of hide, scraps of paper, and barely decipherable body forms are ejected out of a hole in the paper, as if in an explosion. The innumerable oval lines, meeting at the hole, hint at enormous energy potential. The antlers thus appear like the feelers of an insect or the antennae of a transmitting or receiving station, with the dark brown block below functioning as battery; the frame becomes the isolator. Here, Schnabel's view of his art as constituting a field of activity

13

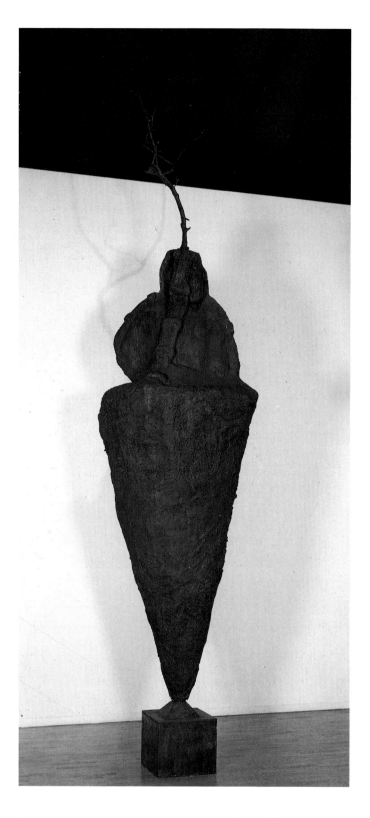

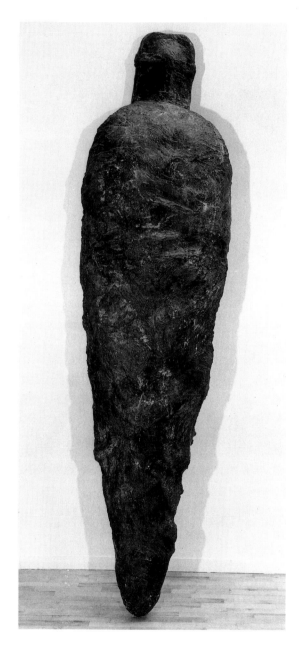

for plastic forces is particularly striking. His concern is to reveal and to generate energy processes. In this, he is similar to Joseph Beuys, though he has never depended on Beuys's theory of an extended concept of art (fig. 13, 14).[6]

In this regard, it is worth noting the following statement which the artist made during a conversation with Carter Ratcliff: "I like to use as many different kinds, I mean; I don't like collecting all this stuff, and I don't like building,

I'm not a carpenter, I don't like constructions particularly and things like that, but placement and the kinds of psychological weight that different materials have is pretty interesting to me. What gold is about…you know? Or what fur is like. Like when you think of Bugatti furniture. Like the upholstery in cars. When things become symbols for fascism. Or what fascism means to us. Or what our notions of classicism are – how we might have an idea about some classical figure, it might be a man in an army uniform or something like that. Because everything I've experienced is somehow assimilated information, as if I lived in the movies – just seeing films about things – but never really *living* it. I guess it's just a kind of distant place. But I'm not terribly interested in just that sort of source material, I think I'm just as interested in finding an old drawing that I might have made, or a drawing that somebody else made or a photograph that might have a certain kind of location in it."[7]

In contrast to *Dead Drawing, Memory of a Crucifixion (Part 2)* (cat. 26) seems composed with greater calm and deliberation. The placement of the rust-red cross just above the center of the sheet gives the impression that it stands at the end of a perspectively receding space. This effect is intensified by the pencil lines converging towards the cross. The ceiling of this imaginary space is indicated in the upper area of the drawing by means of the two obliquely ascending edges of a piece of paper which, as a whole, is reminiscent of an opened envelope. In this way, the cross is solidly fixed in pictorial space, its links with the lower and upper edges of the drawing being particularly important in this regard. The boldly painted structures at the lower left and upper right are likewise crosses, and they, too, can be seen as existing in the illusionistic space. In contrast to the other two crosses, the golden one on the right is depicted in profile, so that the crucified body is seen from the side. This cross is considerably larger than the others and seems to belong to another level of reality: it recalls the miracles given visible form in ex-voto pictures. In this context, the function of abstract symbols of the suffering and death of Christ falls to the cross in the middle: Schnabel sees it as a surrogate for the human body. In comparison, the conical volumes depict a less abstract form of a figure. The bundles hanging from the vetral cross, which are reminiscent of whips, suggest a connection with the martydom of Christ, and the antlers on the scraps of paper at the uppermost edge recall the crown of thorns. Noteworthy in this picture

is the strong orientation, in terms of content and composition, towards a fixed center.

Crosses occur again and again in Schnabel's drawings and paintings.[8] Sometimes, as in *Memory of a Crucifixion (Part 2)*, they recall the biblical event of the Crucifixion (cat. 30-32). In other cases, they form the structural pole of a complex composition (cat. 18, 19). And occasionally, a cross can also become an antenna or a transmission tower (cat. 18) – as in *Dead Drawing* – and can refer to an actual exchange of energy. A whole series of works has individual stations of the cross as its theme, realized in spontaneous, gesturally applied orange wash (cat. 30-32). The monochrome execution of these works leads, in certain areas of the compositions, to dense structures that are difficult to disentangle optically. Behind these networks of lines, bodies and organic forms are sometimes hidden which recall earlier drawings and have marked spatial qualities (cf. cat. 29, 35, 38).

10 Deutsch, *Veilchenstrauß (Bunch of Violets)*,
second half of the sixteenth century
Watercolor and body color on vellum, brush, heightened with white,
mounted on cardboard, $4^1/2$ x 4 in. (11.5 x 10.2 cm)
Graphische Sammlung Albertina, Vienna

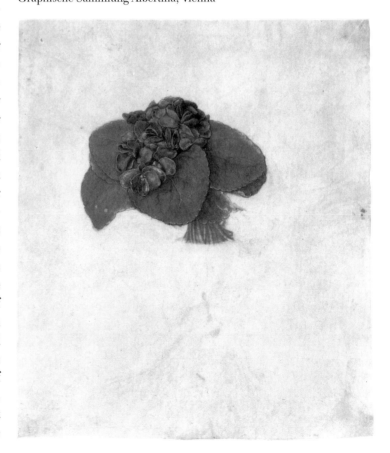

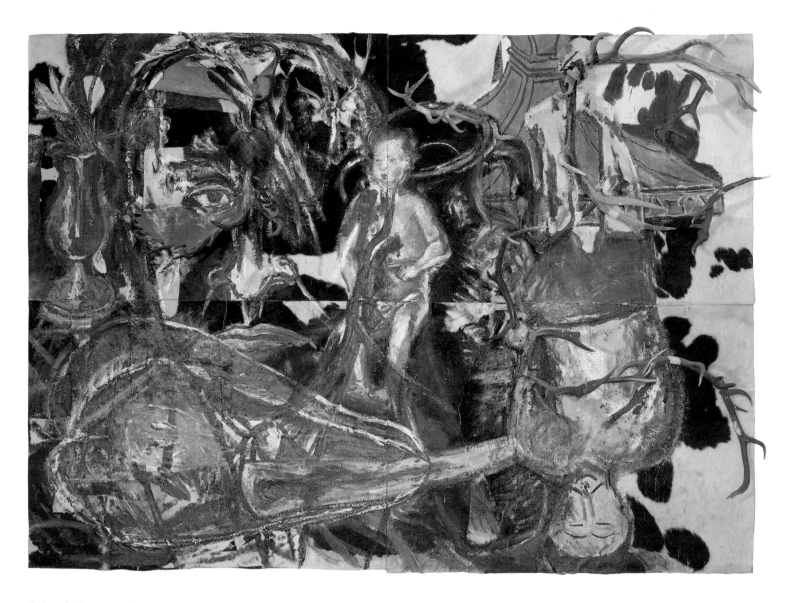

Schnabel's use of maps, beginning in 1980, is based on an effort to locate drawn elements in a broader context. Employing a map as the base of an image of drawing includes a reference to, say, a specific region, an ethnic group, a political system, an economic structure, or a culture. The geographer J. Wreford Watson is convinced that the mentality of a people is determined, among other things, by the character of the place they inhabit, that "the geography of the land is in the last resort the geography of the mind."[9] If a drawing conveys an image derived from reality or from the imagination of the artist, possibly stimulated by the daily work place, that is, a studio or a landscape (cf. cat. 5, 11), then a map, used as the base of a drawing implies the absorption of the composition into a broader, no longer subjectively defined context. A map reproduces a portion of the earth's surface, as if in bird's-eye view, from a great height. This

11 *Prehistory: Glory, Honor, Privilege and Poverty*, 1981
Oil and antlers on ponyskin, 128 x 177¹/₈ in. (325 x 450 cm)
The Saatchi Collection, London

12 *Exile*, 1980
Oil and antlers on wood, 90¹/₈ x 120 in. (229 x 305 cm)
Barbara and Eugene M. Schwartz Collection, New York

picture of the world requires proportional reduction to a manageable size. Schnabel's drawings, however, are deliberately not related to the scale of the maps, since, transferred to the real landscape, they would compete even with works of Land Art. The artist does, of course, play with the notion that a drawing is essentially nothing but a reduction or a concentration of an idea, which cannot really be ren-

16

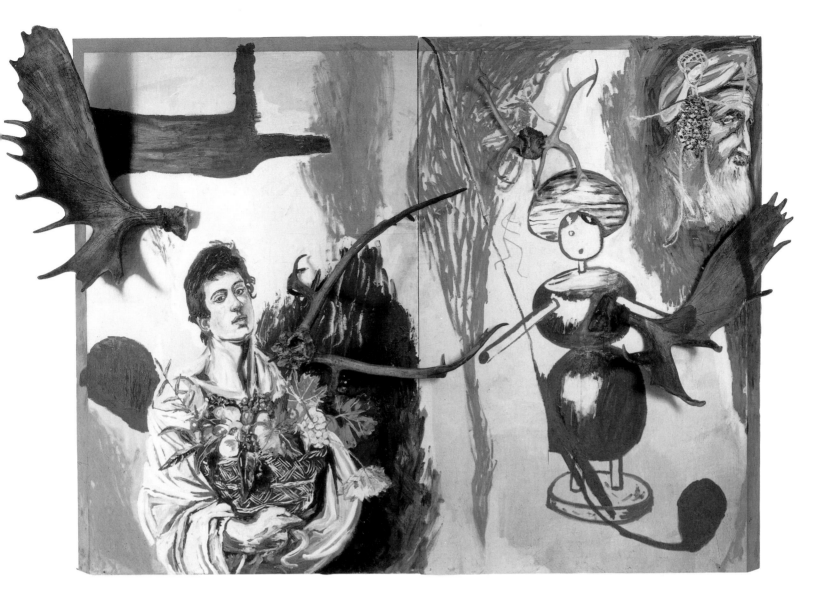

dered in anything but an impoverished form on a piece of paper.

The work of art thus always runs the risk of being impaired by compromises and constraints. In Schnabel's paintings and sculptures, one can follow, step by step, the steady struggle towards meaningful forms and manageable scale. The artist's use of maps, as well as his painting over of broken dishes, animal hides, velvet, tarpaulins, and many other "found" picture surfaces, cannot be explained by a desire to attain the strongest possible expressive impact, but rather, can be traced to a dilemma: art is not the mere translation of an idea, but should reveal the difficulties and problems involved in fixing the idea in a particular medium – in other words, the problem of making visible. Strictly speaking, then, a work is never finished. It is a link in a chain, in an unceasing creative process.[10] This process

transcends the further development of specific motifs and ideas in individual works and even involves the reuse of old pictorial material in new works.

Schnabel's earliest use of a map (cat. 27), in 1980, makes this clear: the pieces of paper relate, in terms of both form and content, to the support surface. The pink square in the center of the aerial map of France and Switzerland, which is turned ninety degrees clockwise, appears like an abstract plane on a foreign ground whose function has been relegated to that of a *passe-partout*. In contrast, the areas that recall leaves, near the edges of the sheet, relate in a certain sense to the topography of the landscape: they can be read as enlarged lakes or small estates.

In *Death of an Ant Near a Powerplant in the Country* (cat. 39), which uses an upside-down map of Europe, one

can make out the outline of houses; towerlike forms which, as the title, indicates, are related to a powerplant; and to the right, a small ant. In this work, Schnabel's inclination to play upon the juxtaposition of the largescale and the small-scale becomes apparent. In *Rose Garden in the Winter* (cat. 41) a comparable situation is captured with expressive brushstrokes. In a blue-violet landscape, a number of flowers, obviously roses, are discernible. The old gilt frame which surrounds the work, and which was carefully chosen by the artist, also establishes a connection with a particular period in the history of art. In previous centuries, drawings were presented in massive picture frames only in exceptional cases. Normally, they were stored in portfolios or albums to facilitate study at close quarters; frames, often extravagant, were reserved for paintings. The frame used by Schnabel bears a plaque inscribed "GUIDO" and must therefore originally have contained a work by the seventeenth-century Bolognese artist Guido Reni. Schnabel thus establishes a relationship between his drawing and the paintings, recently reappraised, of this Italien artist, who produced, in fact, mostly works with religious and allegorical subjects, and hardly any landscapes.

In *View Near Fort Felipe* (cat. 40), a landscape sketch executed with agitated brushstrokes, the creases of a map are all that can be seen of the support. Here, the viewer

does not know if the support – covered with black, rust-brown, white and marine-blue colors – is really a map of the region mentioned in the title. The drawing dates from Schnabel's 1982 vacation in Port'Ercole, the death place of Caravaggio, and shows him working with his impressions of the nearby Fort Felipe.

In most cases, Schnabel's work on maps have little to do with landscape or nature studies, but rather, are freely in-

vented artistic statements and only partly visual translations of the geographical characteristics of a country visible on the map (cat. 54).

The thematic richness of the works on maps, all stemming from an atlas of Italy from of the Italian Touring Club, is especially great. There are altogether eleven works, four dating from 1983 and the rest from 1987. The earlier works are all painted in red-brown oil color. The pictorial motifs can be partly explained as a translation of the artist's own motifs in relation to the map base. Thus, one work (cat. 42) shows similarities with the 1981 painted portrait of Antonin Artaud, while in another (cat. 45), a ballpoint pen drawing from 1978 (cat. 9) has been transposed onto the map. These examples illustrate how Schnabel operates not with finished artistic solutions, but rather leaves the possibility open of applying them later within a new context. A grimacing face on the Adriatic coast somewhere below Pescara (cat. 43) is reminiscent of a stranded sea monster meeting a horrible end. A relationship to the topographical facts of the reproduced landscape is sometimes apparent in these works, but this is not a general principle. In the case of above mentioned drawing (cat. 43) Schnabel clearly had recourse to a specific model, a drawing of a grotesque head by the Renaissance master Leonardo da Vinci. On another map, the body of a curled-up cat fits elegantly into the Golfo dell'Asinara on the north coast of Sardinia (cat. 44).

For Schnabel, maps are also important inasmuch as they precisely reproduce the surface of the earth, thus representing a meaningful basis for a drawing in a way that is comparable to the relief surface produced by the broken plates in his paintings. In both the drawings and the paintings the ground is more than just a surface to be worked on: it is the specifically chosen place where artistic images and ideas can make their appearance. A map, therefore, means more than a scientific record of a geographical area. The various cultivated, built-up, or untouched regions, the mountains and valleys, the rivers and lakes, are all features and particularities which imbue the surface with the characteristics of a landscape. In some drawings, one feels that the artist experiences a map as a skin, with all its pores, hairs, wrinkles, scars, and wounds.

The drawing *Die Elbe* (cat. 47) confirms these assumptions. The artist has stressed the mouth of the river with brown oil color. The result is a hybrid of dolphin and bird, which seems to emerge with an elegant swing from the now heavily polluted water of the River Elbe. The lower half of the work relates directly to the map: the two pink lines can be associated with either the course of a river or with the traces of a wound which is covered by a piece of cardboard pasted onto the drawing and bearing a mysterious black cross or clover leaf — a reused work from 1981.

The works on maps entitled *Letter to My Wife* (cat. 58 - 64) constitute a group which differs substantially from the earlier geographic drawings. In the first works of the series, Schnabel used black-and-white or palely colored nautical maps. The background is formed, not by colorful mainland, but by coastal regions and the monotone areas of water, which are indicated by a fine network of lines and sometimes animated by the different blue tones of the depth levels. Here, the map is not given a graphic commentary; that is to say, the varied coastlines of northern Spain, Scotland, Ireland and Norway, are not the starting points of fantastic figures or abstract structures, as had been the case in the works using maps of Italy. Schnabel allows himself to be stimulated by the nautical maps, but superimposes on them totally new compositions which take over the entire surface of the map — images that bring to mind the creation of the earth or mythical eras from the dawn of history.

Enormous masses of rock emerge from the waves, mountain chains are visible on the horizon, or a mysterious horizon opens up across the center of a drawing. In other works from the group, there are strange shieldlike forms and giant letters. The intensity is increased in various ways — for example, by the glueing together of three parts of a map to form one sheet (cat. 58). In this drawing, the irregular edge of the lower, torn strip, painted with violet and beige, suggests a mountain ridge. Here, the impression arises of brief stages in a journey at sea somewhere near the north coast of Ireland. On a map of the Scottish coast (cat. 61), enormous masses of rock seem to emerge from the water.

Despite the possible relationship with the support, these are new images. One should not forget that Schnabel intended these works to be understood as letters, as intimate confessions to his wife. On these maps, he reports on trips and, in images and letters, captures certain impressions. The capital letters on several works (cat. 59, 62 - 64) are the initials of his wife's maiden name, "JB" (Jacqueline Beaurang), while "AVG" refers to her first names (Anne, Vera, Georgette), and "S" to her surname (Schnabel).

The works can also be related to real or symbolic journeys required by the artistic process; that is to say, to the meaningful widening of the artist's horizon by the tracking

down or discovery of foreign territories. Seen thus, the letter acquires crucial significance, especially if, as the drawings seem to indicate, the voyages are to remote areas.[11] An additional element is provided by the rectangular opening, lined with velvet, which appears towards the bottom of all the maps. It makes clear that the real reason for, or the thematic substance of, the drawing lies still deeper than the bottom of the sea, visible on the map, and apparently remains to be discovered. In the final work of the series (cat. 64), the landscapes, letters, and symbols have grown together to form a unity and can be read as artistic images of those hidden sources of energy that lie deeper than the bottom of the sea.

At first glance, the works on paper from 1987/88 (cat. 65-71) call to mind Robert Rauschenberg's Combine Paintings. In his animated compositions, Rauschenberg had used shreds of cloth, newspaper photographs, postcards, and other elements from everyday culture. Schnabel uses his own works from earlier creative phases or prints after well-known paintings. These prints, including the *passe-partout*, are placed at the optical center of the work and integrated into the composition by means of color accents. Irregularly cut canvas *passe-partouts* surround the works. Here, the question of framing (that is, the traditional form of displaying a print, drawing, or painting) becomes the most important aspect of the work's content. The print is accentuated by the rich treatment of its surroundings (cat. 67-71). The works discussed above that relate to the problem of framing (cat. 20, 21, 28, 40, 41) seem modest in comparison to this later group, in which a print is often surrounded by two *passe-partouts* and a heavy wood frame. The subject of these drawings can be understood as artistic work *per se*. Every work of art, whether by Schnabel or by another artist, regenerates itself continuously and therefore has to be seen in an ever-new light. Seen in this context, parts of some of Schnabel's drawings do indeed recall film images or a sequence of movements (cat. 49, 50).

The blue canvas with a wire cross in the center of *Flag from the Raft* (cat. 66), points to an earlier phase in Schnabel's career, originally having belonged to the plate picture *The Raft* (fig. 15) of 1982. This pressed canvas,

15 *The Raft*, 1982
Oil, plates, and bronze sculpture on wood,
108 x 228 in. (274.3 x 579.1 cm)
Collection of the artist

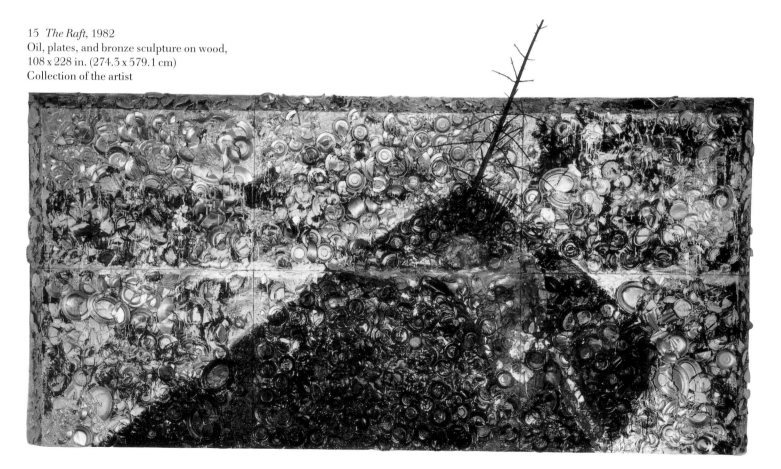

without stretcher, sits atop a violet bar which extends at both ends to the cloth *passe-partout*. The white paper surrounding the image is painted grey and violet in places. Beneath the bar, and slightly to the left of center, is a sheet from a sketch pad that bears a dark violet spot. The image in the center seems to be artificially accentuated and has a temporary air. Above all, it is by placing it on the paper background that Schnabel calls into question the medium of painting. In the plate picture mentioned above, the blue canvas was attached to the trunk of the fir tree which protruded into space, thereby taking on the role of a flag. Now, stripped of its original function, it becomes the focus of a new composition, in which the relationship to the raft is no longer apparent. At the most, the original pictorial idea is recalled by the violet line, which may be read as a horizon of water.

In *Confused Girl* (cat. 68), the artist goes one step further by including, not one of his own works, but a print by Pierre Charles Ingouf the Elder after the oil *La fille confuse* by Jean-Baptiste Greuze. Attached to the very center of the picture, this print depicts a kitchen scene with a maid and an old woman. The maid apparently finds herself in a hopeless situation as a result of her loose conduct and of the overwhelming burden of her work. The old woman, who looks in through the kitchen window, is incapable of changing the situation with her comments or advice. The violet beams which grasp the print from above and below like a pair of tongs, create a situation similar to that in *Flag from the Raft*. Here, too, there is a connection with painting, since the print reproduces an oil painting. The ascending

heart or leaf shapes seem to transport this scene, which derives from seventeenth-century Dutch genre painting, to a more opulent environment. The violet-colored shapes emerging from the lower edge of the *passe-partout* give the impression of butterflies flying away from the earth, thus again creating a connection to the starting point of artistic work. Schnabel's art cannot be explained in terms of a gestural painting technique derived from Abstract Expressionism, but rather, in terms of a belief in the continuous regeneration of existing creative potential. Thus, strictly speaking, nothing is created anew, but already exists and has only to be brought to life. With reference to painting, Schnabel explains his attitude on this point as follows:

"Everything has existed before. For me there's no achievement in making a graphic description of myself, my personality, on canvas. Using used things, things we all recognize, is in direct conflict with the idea of building your own, specific original signature that will isolate the image you make from all others. Using already existing materials establishes a level of ethnographicness in the work; I mean it brings a real place and time into the aesthetic reality. Its selection can locate a place, a cultural familiar or exotic, self-made or procured. This is the platform for the mental and physical structure within the painting. The selection goes beyond the style of the signature of the artist."[12]

In his drawings, Schnabel at once reflects and questions a specific time. He continuously orients himself by means of given locations, makes them his themes, and distances himself from them again. Schnabel's art is everywhere and nowhere: between heaven and earth.

NOTES

1 In this regard, see especially the following two reviews of Schnabel's 1987 one-person exhibition at the Städtische Kunsthalle, Düsseldorf: Petra Kipphoff, "Gott und die Welt und J. S., Ausstellung in Düsseldorf: Julian Schnabel – Bilder 1975-1986," *Die Zeit*, 21, May 15, 1987, p. 62; Werner Spies, "Der starke Mann und der Markt: Der Amerikaner Julian Schnabel in der Kunsthalle," *Düsseldorfer Hefte* 32/9, May 1, 1987, pp. 8-9.

2 Julian Schnabel, *C. V. J.: Nicknames of Maitre D's & other Excerpts from Life*, New York, 1987, p. 113.

3 See René Ricard, "About Julian Schnabel," in exhibition catalogue, *Julian Schnabel*, Stedelijk Museum Amsterdam, 1982, unpaginated; Gert Schiff, "Julian Schnabel and the Mythography of Feeling," in exhibition catalogue *Julian Schnabel*, The Pace Gallery, New York, 1984, unpaginated.

4 According to the latest research, *Nosegay of Violets* is not by Dürer. See Fritz Koreny, *Albrecht Dürer and the Animal and Plant Studies of the Renaissance*, Boston, 1988, p. 218.

5 See Martin Schnöller, "Malerfürsten im 19. Jahrhundert. Hans Makarts Atelier in Wien, die Villen von Franz Lenbach und Franz von Stuck in München," in *Künstler-häuser von der Renaissance bis zur Gegenwart*, ed. Eduard Hüttinger and Kunsthistorisches Seminar of the University of Bern, Zurich, 1985, pp. 195-217.

6 See Matthew Collings, "Julian Schnabel in conversation with Matthew Collings," in exhibition catalogue, *Julian Schnabel: Paintings 1975-1986*, Whitechapel Art Gallery, London, 1986, pp. 89-92.

7 Quoted in Carter Ratcliff, "Julian Schnabel," in *Interview Magazine* 10/10, October 1980, p. 55.

8 See Kevin Power, "The Pain of Recognition: Julian Schnabel," in exhibition catalogue, *Julian Schnabel: Reconocimientos, Pinturas del Carmen*, Cuartel del Carmen, Sevilla, 1988, pp. 50-53.

9 Quoted in Svetlana Alpers, *The Art of Describing: Dutch Art in the Seventeenth Century*, Chicago and London, 1983, p. 125, note 5.

10 See Thomas McEvilley, "The Case of Julian Schnabel," in exhibition catalogue, *Julian Schnabel* (note 6 above), pp. 9-19.

11 See Alpers (note 9 above), pp. 192-207.

12 Quoted in exhibition catalogue, *Julian Schnabel* (note 6 above), p. 97.

Donald Kuspit

Julian Schnabel's Expressivity

Drawings are customarily intimate works, communicating the deepest emotional and conceptual interests of an artist in a spontaneous, direct, "handy" way. However slowly it may be executed, a drawing is usually experienced quickly, so that the artist must be in full possession of his interests and the viewer poised for instant and full understanding. The drawing offers little room for reflective maneuvers, the way a painting or a sculpture does. It seems more expressively immediate than they are, so that its material and form seem to be entirely in the service of its expressive power. It is an all-or-nothing, hit-or-miss communicative effort. It must be surprising, so that we are moved before we can have second, "theoretical" thoughts. If it is not, if it raises intellectual doubts that interfere with its expressive impact, it tends to seem beside the serious artistic point — too materially slender to be far-reaching, meaningful. The successful drawing — one that, even if it is a preparatory study for a painting or sculpture, seems an end in itself — is difficult to make, for it must cut through the artist's own resistance to quintessential articulation, as well as that of the viewer. Not only is such articulation hard — and dangerous — for the artist to achieve, because it may force a premature peaking of purpose, leading to exhaustion before the artist has fully defined himself: the result may seem too reductive for emotional comfort, too didactic to be expressively persuasive. In a good drawing, quintessential articulation must be expressively dense — an intensification rather than dilution of expressive effect.

Julian Schnabel's drawings are particularly impressive in that they show an artist known for his theatrical grandeur to be capable of subtle, intimate emotional articulation. Indeed, he utilizes his theatricality to articulate complex, delicate emotion — refines his theatricality into an instrument for an investigation of interiority. His drawings offer a kind of apotheosis of the idea of irrational emotion: he stages the moment of intense emotional drama — indeed, emotional crisis — in a way that makes it seem transparent while retaining a sense of its mystery and intensity. In the drawings, his theatricality is explicitly intellectual, subserving a kind of dissection of signifiers of human emotion. Schnabel's drawings reveal a different side to his persona than his paintings and sculptures, although many of the same motifs and methods occur in all three. The drawings indicate the subtlety of his sensibility, while his paintings and sculptures show his will to make a statement. In his drawings deliberate will and idea — the struggle for conviction — are not the issue, but rather what might be called a free associational — gestural — response to an image that is culturally willed and over-intellectualized, its meaning so fixed and institutionalized as to no longer be felt. Schnabel frees it from its sociophilosophical bondage, recovers the living spirit that informed it. In general, Schnabel starts from what seems final and fated in its givenness, and undoes or unmakes it, in the process seeming to recover the irrational feeling "originally" invested in it. He goes against known and finished form to uncover the strange emotional energy that "in-forms" it. He implies that form exists to estrange us from and obscure the very emotion that it exists to communicate, and so must be undone by the unform of gesture. His drawings are predicaments, in which the tension between the articulate and the inarticulate is dialectically rendered.

There has been much talk of Schnabel's historicism — his Postmodernist allusion to past imagery — but what counts (as it has since Duchamp's readymades) is the character of the imagery he chooses and his psychoartistic response to it. Quotation as such is beside the point; what matters is how the Postmodernist artist exposes his interests through his appropriation. Thus, in the two drawings *Source Material for: Glory, Honor, Privilege and Poverty*, both 1983 (cat. 46a, b), what is important is not the use of photography — mechanical reproduction — but the unmechanical way the reproductions are presented: their worn, tattered, used and abused condition, "enhanced" by Schnabel's gestural touches. What also counts is the detail of the famous Northern Renaissance works shown: the emphasis on the flowers in the one case; and, in the case of Jean Fouquet's *The Madonna of Étienne Chevalier* (the right panel of the Melun

Diptych), the strange character of the relationship between the Child and the erotic Madonna (Agnès Sorel, the mistress of Charles VII) – her revealed breast virginal and firm rather than maternal and soft and full, and so unable to nourish the child, which makes it all the more sexually exhibitionistic and tempting. Schnabel moves away from the grandeur of the work as a whole to the emotionally telling intimate detail – the detail fraught with private meaning within the officially public work, the detail that in fact undermines the public and official meaning of the work. He moves away from the establishment/institutional identity of the work towards its emotionally immediate effect – an effect that makes it less discursive and more "instinctive" in appeal. In a sense, he wants to unpack the emotional mystery that is concentrated in this intimate detail. He in part accomplishes this by making it "dysfunctional" in terms of the totality of the work – no longer "fitting" in it. It is a part that can stand – because it stands on emotional ground, is isolated as an emotional signifier – without looking back to the whole.

The reproductions that interest Schnabel are fraught not only with emotional but with temporal import, adding to their sense as signifiers of interior "events." Schnabel is not interested in reproductions as such, but in the fact that the art reproduced belongs to the "legendary" past. Its character as both reproduction and as "historical" representation distances us from it, neutralizes its "original" – immediate, living – effect. (Indeed, whatever is reproduced is automatically historicized, as it were, and part of what it means to become historical is to become reproducible.) This makes the problem of bringing the historical reproductions to emotional life greater, but it also suggests that they have a deeper emotional life than contemporary imagery. Schnabel's gesture, full of concentrated power and complex in import – at once convulsive and magisterial, Dionysian and Apollonian, full of libidinous insistence but also like a drop of "intellectual blood," to use a phrase of Breton – immediatizes the reproduction, seeming to overcome or at least question its historical character, restoring life to it without denying its pastness. The gestures stand in a tense, defiant relation to the historicity of the reproduction as well as to its character as reproduction. They are, I want to suggest, a way of externalizing the life represented by and sedimented in the historical work of art, and in the living work of art "memorialized" as well as made impotent by the reproduction. Schnabel's gesture raises the Lazarus of life and art from its grave in history and reproduction.

Let us look more closely at Schnabel's intention, and the process by which he accomplishes it. He can be said to turn culturally given iconography into psychoiconography, that is, he transforms a culturally given monument into a psychosignifier, in effect "desublimating" it. He subjectivizes culture in a way reminiscent of how Beuys subjectived nature. In a sense, Schnabel's task is more difficult than that of Beuys, because nature has for a long time been an accepted signifier of subjectivity in art, whereas culture is supposedly trans-subjective. The various quotations from Michelangelo's Sixtine ceiling show this moment of "conversion" in a particularly conspicuous way. Indeed, Schnabel in general is fascinated with the intense emotionality, in which a being's all seems concentrated, of the moment of conversion, as *The Conversion of St. Paul* of 1979 (cat. 19) indicates. A conversion implies a radical change of outlook, which seems pathological in character but is in fact healing, especially of the sense of banality that haunts and threatens vitality, the constant trauma of everydayness that deconcentrates being. (It is the trauma of banalization that has become matter-of-fact and casual in mechanical reproduction.) The sense of spiritual mission that comes with conversion parallels Schnabel's sense of the mission of art We see a seemingly traumatic moment of healing conversion – an apparently irrational moment of dramatic psychic change – articulated and made emphatic by Schnabel's gestural "bracketing" of it. The gesture itself seems to embody the lightning-suddenness of conversion.

An untitled 1979 collage (cat. 18) utilizing Michelangelo's image of the heroic Christ in the *Last Judgment*, with His arm, dramatically raised above his head, about to come down on His "victim," and His body half-standing/half-sitting – a dynamic pose much utilized by Michelangelo, to convey uncontrollable inner power (for example, in various Sibyls and the Moses sculpture) – makes the point succinctly. The image is positioned like a relic in a pyx of theatrical gestures, and canceled in Heideggerian fashion, that is, problematized, phenomenologically bracketed. This converts it into a subjective signifier, makes it subjectively resonant, seems to restore it to emotional significance. Schnabel's "white" lightning gesture of artistic judgment cancels Christ's "black" lightning gesture of moral Judgment, through the act calling attention to the emotional strangeness of Christ's gesture. It is shown to be a "compromise formation." That is, Schnabel's dramatic cutting of Michelangelo's image discloses Christ's overtly physical gesture as a vector embodying the conflicting emotions

– the tension – He has as He makes His judgment. Schnabel suggests, in effect, the uncertainty of indecisiveness of Christ Himself. To have the final word – to make the last judgment – causes Him suffering. Schnabel is interested in the dramatic character of Christ's moment of decision – a moment of "conversion" – because in it contradictory emotions are concentrated and converted in to the physical "symptom" of a gesture – artistically somatized. In a sense, the lightning that Zeus-Christ's gesture hurls reaches to St. Paul, causing his conversion – the stroke of inspiration "enlightening" him – and also implies God's "conversion" to the "cause" of Paul's being, that is, that God is on Paul's side. Indeed, the moment of dramatic conversion – ultimately embodied in the contradictory character of Schnabel's gesture – is formative of God's as well as Paul's being, and is a form of the life – spirit. Schnabel is a master at articulating this double sense of gesture: as formative, and as a form – end – in itself. This is the "feminine" moment in art, the moment of creative transformation; Schnabel is fascinated by and master of its mystery.

Schnabel's drawings, then, tend to be a sum of gestural details that challenge a fixed order and view of things. By dramatically overturning it they imply its inadequacy to emotion, and suggest the very means of effecting the overturning – the gesture – as the adequate-to-emotion alternative. This is perhaps most evident in the numerous drawings in which maps are gesturally overpainted, particularly those of Italy. Here the gestures emotionally archaicize a contemporary world, while in the drawings that utilize reproductions a historical art is emotionally archaicized and given contemporary impact. Schnabel in effect takes an abstract *mappa mundi* and personalizes – converts – it into a psychic *hortus conclusus* – an emotionally adequate zone – by means of his dramatic gesture. Sometimes the gestures converge into a hallucinatory face or other recognizable image, usually the living landscape "behind" the dead map, but also the living letters of indeterminate emotional meaning. At other times Schnabel's gesture seems dynamically arbitrary, a cut live wire existing for itself, but also in elective affinity with other such gestures – a sum of details that often makes an indeterminate or at least unfixed whole. The gestures are always more intimate in import than the map, and dwarf it with their scale. Indeed, part of the power of the drawings is the reversal of scale they effect between the objective world of the map and the subjective world of the gestures: the intimate world of subjective gestures be-comes grander than the objective "gestures" of the world of the map. In fact, Schnabel's gestures exist in erratic reciprocity with the details of the map that are their pictorial ground. An irrational intimacy exists between the "figure" the gesture cuts and the ground on which it "rests," generating an uncanny emotional effect that makes the map oddly fresh – makes it seem like a Rorschach drawing. Au objective map has become subjective laudscape – irrational terrain.

At first, map and expressive gesture seem incommensurate and irreconcilable – and yet Italy, the proverbial South, is a world of clichéd expressivity, a world in which communication occurs through routine, stylized, systematically theatrical gestures. Schnabel undoes the objective code of expressivity – the stereotyped theatrical expressivity – of Italy, restoring its emotionally vital core, recovering the lability that makes it "Southern." In general, Schnabel "emotionalizes" whatever "scene" he touches – whatever conventionally mapped, objectively measured world he "renders" – making it freshly immeasurable, recovering our sense of it as enigmatic terra incognita, which is its subjective core. Schnabel's subjective gestures unsettle the objectively, stereotypically determined world the way an earthquake would. Or rather, they are tremors within that world, signifying unexpected expressive "faults" in it – its unexpected, hidden subjective character and vitality. Schnabel articulates it at the moment it is about to lose form, if not become altogether formless. Yet the drift to the formless – to what Kohut calls "prepsychological flux," what Winnicott calls chaos – exists in the drawings. Schnabel wants to possess this chaos – this sense of the world before it was decisively formed – for contact with it is the secret source of creativity. He is looking for the secret of eternal creativity, and he may have found it. Schnabel is an artist of both cosmic and intimate proportions, putting outer and inner worlds in a dramatic, creative relationship in which they seem to exchange properties: the emotions of the inner world are shown in the process of being given form, and the forms of the outer world are shown in the process of dissolving into emotional chaos.

In a sense, Schnabel takes a found element – an abstract gesture or representational "image" – and makes it seem less than adequate to emotion. One way of making each seem more adequate to emotion is by changing it into its opposite: Schnabel shows abstract gestures in the process of converging – converting, changing, forming – into images, and images in the process of dissolving into "formless" ges-

tures. The presentational becomes representational, the representational presentational. The line between them becomes blurred, and finally completely obscured. This process of reversal – transvaluation – of visual values gives the drawings their hallucinatory import: their odd mix of the transitory (appropriate to gestural drawing) and the weighty or "grave" (appropriate to representational painting and sculpture). Schnabel seems to monumentalize gesture without losing the sense of poignant transience it communicates, and gesturalize – immediatize – monumental representations without losing a sense of their commemorative import. This is a difficult, rare double feat. Both gesture and representation tend to be presented in an isolated way: the amorphous field of the paper becomes instrumental in the uncanny hallucinatory effect. The isolation is simultaneously emotionally ennobling and intellectually alienating – exactly the effect of hallucination. Schnabel's drawings are wonderfully uncanny, that is, they communicate a sense of repressed emotion in the process of returning, but not yet completely returned, completely clear in character. It is vehemently displaced onto the world, but still obscure, which is why it seems simulateneously erotic and aggressive – ambivalent.

A similar sense of uncanny dread – conventionally the feeling of going mad – pervades Beuys's drawings, but they move in a different direction. Where Beuys always recurs and holds fast to objective nature – it is exactly because of its literalness that it is powerfully expressive, that is, a healing *Urquelle* – Schnabel deals with subjective nature that has been mythologized into oblivion, that is, trapped in the forms used to represent and communicate it. Intellectually and aesthetically rationalized rather than expressively intact nature is his point of departure. Like a Danube School artist, Beuys struggles with an unmasterable objective Landscape to which he must submit; Schnabel deals with a seemingly completely mastered subjective Landscape, which can be revalidated and revitalized only by its re-irrationalization, as it were.

Yet Schnabel is clearly interested in both the intellectual surface of the psyche – its power of mapping – and its emotional depths, that is, its power of expressing. In general, the intellectuality of his art is underestimated, but in his drawings, where a judicious balance is maintained between concept and emotion – where emotion is conceptually rendered – it is self-evident. Indeed, in his purely gestural works, he manages to deconventionalize – without giving us a new myth of spontaneity – the by now historical, standard, well-mapped, overobjectified gesture itself, restoring to that "sign" its contradictory character as literal expression of raw passion and abstract articulation of autonomy.

Schnabel's drawings are perhaps his most quintessential works, as emotionally and intellectually if not as physically large as his other works. Above all, they make explicit the special unity of the lyrical and the epic that is implicit in the larger works, but obscured by their theatricality. In contrast, as I have argued, the drawings finesse theatricality in the very act of utilizing it, just as they finesse anguish in the very act of representing it. The drawing is usually understood as the embryo of an idea. We can say that Schnabel's drawings are embryos of the idea of the solitude in which conversion occurs – the solitude of the judging Christ, of Paul. It is a solitude that can never be adequately presented theatrically and that exists within the anguish that represents it. In a sense, Schnabel shows us how representation can become a revelation of what seems beyond presentation.

Brooks Adams

Julian Schnabel: An American Perspective

It has now been ten years since Julian Schnabel burst upon the New York art world with his broken-plate paintings, and the extent to which both the changes and the continuities within his work have affected this decade's art has been extraordinary. Schnabel was among the first to startle us with paintings so bulky they almost took up entire rooms with their sharp and highly irregular surfaces. Artists as different as Frank Stella and Elizabeth Murray, David Salle and Judy Pfaff, have also caused a stir with high reliefs, before, during, and after Schnabel's plate painting phase.

In 1983, when Schnabel went even further in the direction of high drama with colossal bronze sculptures that seemed to ring in some new and disturbing Age of the Nibelungs, we accommodated them almost as if we sensed that such monstrosities had always been lurking under the pleasances of 70s sculpture. Next to the tiny bronze houses of Joel Shapiro – who, as it happens, owns two of Schnabel's drawings (cat. 29, 34) – these things looked like gargoyles and poltergeists assembled for some Black Mass. And these bronze amphorae and totems (cf. Schnabel's *Drawing for Sculpture*, cat. 41) were a likely catalyst for younger artists' jugs and totem poles, made of everything from ceramic to fiberglass, which suddenly cropped up all over town.

For all his Wagnerian excess, however, Schnabel was simultaneously clearing away all the mess. As early as 1980, there were drawings of an almost conceptual spareness (cf. cat. 27), a quality that he amplified dramatically in huge paintings on weathered tarps. The ascetic streak stands in marked contrast with the *horror vacui* richness of the plate paintings, and this dialogue remains a constant in his work. For example, the tarp paintings of 1986 – with words such as "Virtue" written on tiny, attached religious banners – suggested the possibility that the artist had entered a phase of rigorous soulsearching. Recent additions to his word-and-image repertory, however, including such succinct concrete poems as *I Hate to Think* and *Ri de Pomme*, exist on a scale that remains extravagantly, flagrantly operatic.[1]

Schnabel's drawings encompass as broad a gamut of styles and scales as the paintings. They range from small notebook pages to palatial collages, from Rorschach-like scribbles to relatively straightforward landscapes and portraits – even a ballpoint sketch of Marlon Brando, which ran in a recent issue of *The New Yorker*.[2] In one untitled drawing from 1979 (cat. 21) Schnabel manages to get a detail of Michelangelo's Sixtine Sybil going against a ground of abstract camouflage patterning and a frame of real cowhide. Schnabel, in fact, defines drawings as "anything on paper."[3] Indeed, his conversation on the subject of drawing encompasses painting, sculpture – even acts of weather. But this is not so peculiar coming from an artist who emerged during a period when an exhibition such as "Drawing Now" at the Museum of Modern Art, New York, in 1976 included everything from inkblots to earthworks.

An untitled study of a column from 1976-77 (cat. 2) can, at first glance, seem strangely mute and laconic – like a great deal of mid-70s art that owed something to the unemphatic gestures of a Richard Tuttle. Yet in retrospect, the drawing also seems auspicious as a new image – and not just the kind of deadpan, so-called "New Image Painting" that was enshrined at the Whitney Museum of American Art, New York, in 1978. As a marker of Neoclassical imagery within Schnabel's work (his first broken-plate painting, *The Patients and the Doctors*, of 1978 [fig. 4, p. 10], contains such a column) the drawing should be seen as an important signpost of the whole Beaux-Arts revival that came to be known as Postmodernism. Schnabel's column is characteristic: not only is it lightly festooned with pointillist markings (harbingers of the broken-plate technique?), but it is shown cut off – not structural or weight-bearing – and it is notably unoccupied on top. Unlike the upside-down column that, in the 1981 cowhide painting called *Prehistory: Glory, Honor, Privilege, Poverty* (fig. 11, p. 16), would be the perch for Simon in the desert, this mid-70s column seems to wait for a sitter: in a way, it is a forlorn and tenderhearted image.

Like his plate paintings, Schnabel's late-70s drawings have lively, broken-up surfaces. By the time he saw the

great Joseph Beuys retrospective at the Solomon R. Guggenheim Museum in late 1979, Schnabel had already made a number of drawings with stains on them (cf. cat. 4, 6). The Beuys show, however, – a revelation for a whole generation of American artists – confirmed Schnabel's feeling for "art as a utilitarian thing – even if it's primitive, made with a pencil or stain, it becomes magical – a point of catharsis." Schnabel seems in particular to have been affected by Beuys's use of inkblot ambiguity and torn-paper collage, and with these devices established new climates for landscape and figure drawing. *Christ Entering Zihuatanejo* (cat. 29) is a prime example of Schnabel's Beuysian style: with its carroty figure and exquisite orange-on-blue beachscape, it echoes some of the whimsical humor and beauty of Beuys's 50s watercolors, only now on a much larger – some might say typically American – scale. (Schnabel describes this seaside work as "Christ and the electrical storm he's causing.") Its title also seems like a strange fusion of Old and New Worlds: Schnabel sitting on a Pacific beach in Mexico thinking about James Ensor's *The Entry of Christ into Brussels in 1889.*[4]

Pursuing a sensibility he sees as "distinctly un-American," Schnabel also found the example of Cy Twombly "revitalizing." According to Schnabel, it was not until around 1980 that Americans began really to find "important use for Twombly and Beuys." Until then, says Schnabel, "Twombly was seen as a minor master." With the insight born of safe generational distance, Schnabel could also see affinities between Beuys and Twombly that had never before been apparent. This insight is reflected in Schnabel's resolve to make grand-scale American art with a determinedly European cast, which, rather like Henry James's heroines, seems perfectly at home in Roman palazzi, Spanish convents, and Mexican haciendas.

"A drawing in frenzy," are Schnabel's words on the subject of *Dead Drawing* (cat. 28) of 1980, which has a form at the bottom that he further describes as "a plunger for dynamite." Above the plunger, an arc of black and white cowhide slices across the paper and penetrates a cut-out hole, thereby providing, among other things, a savagely elegant update on Cubist *passage.* The use of cowhide in this and other works, so like the covering on Le Corbusier's famous chaise longue, also projects a grand and novel sense of International Style *richesse.*

Schnabel's map drawings tap a very peripatetic autobiographical vein. In Switzerland, Schnabel made drawings on some maps he had bought in St. Moritz. While in Belgium visiting his wife's family, Schnabel found some maps belonging to his mother-in-law – the first woman pilot to cross the Channel in a helicopter – and proceeded to draw on these as well. He also remembered the work of his old friend from Texas, Michael Tracy, who, in the port town of Galveston, had made map drawings with the help of some visiting Chinese sailors. In 1983, Schnabel made drawings based on figures in the Leonardo sketchbooks and superimposed them on maps he bought in Italy. (In one such drawing [cat. 43] a growling face seems to lick the coastline, recalling the ancient tradition of personifying storms as great blowing heads.) For Schnabel, who spends a lot of time in the water, surfing and whatnot, the maps are also "points of embarcation." And, overall, the map drawings seem hermetic and traditional, almost as if through them Schnabel were retracing the routes of trips taken by himself and his mythic forebears.

One odd and amusing map drawing (cat. 54) from the series "Notes from a Bad Summer" of 1987 features a leg with a shoe on it suspended over a map of Italy, and a tiny cartoon figure hanging off what looks to be a garter. This seems to be not only a joke on the boot of Italy, but also a play on Andy Warhol's *A la Recherche du Shoe Perdu* (1955). And here again we enter a vortex of coincidental styles and subjects. The early Warhol drawings, for instance, seem to have spawned even more youthful offspring in the work of Donald Baechler, whose 1988-89 drawings of socks (as well as crowds and tulips) in fact seem close in spirit to both Schnabel and Warhol. The little figure dangling in Schnabel's drawing of a leg, for instance, might be a big brother for Baechler's Playskool boys and girls – here indulging in a bit of gallows humor. For Schnabel, the "Bad Summer" drawing has to do with "feeling strangled by love," a stricture he associates with the man in Stroheim's *The Blue Angel,* who, in the thrall of Marlene Dietrich, just "lost everything to a leg."

Schnabel often seems like a sort of lightning rod, conducting tremendous energies to and from other artists' work. His most symbiotic relationship, he says, is with the painter Ross Bleckner – who in fact owns the magnificent *Dead Drawing.* Recently they have both showed work with vaporously atmospheric grounds. Among younger artists there is also George Condo: Schnabel affectionately describes Condo as "someone who draws all the time, even while watching TV," and this image-gobbler's work in turn mirrors some of Schnabel's European, Surrealist, and – not

least – Picassoid obsessions. Farther afield, even the strange sink sculptures of Robert Gober – they look as if they've stopped short somewhere on the Darwinian ladder – suggest what is perhaps a quintessentially Schnabelian vision: the gloriously ruined, or obsolescent, future.

The alternating poles, in Schnabel's work, of ascetic spareness and princely richness can often be present in a single work. His on the face of it simple image of a crucifix with Chinese lanterns (cat. 16, 19, 26) – inspired by a scene in Jean Vigo's *Zéro de Conduite* – turns out to be a marvelous compost-heap of mixed metaphors. Schnabel is quite a maverick iconographer. According to him, for instance, the lanterns are "the two criminals on either side of Christ." The subject of crucifixion occurs throughout the œuvre, in drawings like *The Conversion of St. Paul* of 1979 (Cat. 19), with its polyphonic quotations from Michelangelo; in broken-plate paintings like *Vita* (1984), the female crucifixion which is a portrait of the fashion-model and artist Veruschka; and most recently in the colossal 1988 cruciform sculpture *Idiota*, which Schnabel and his assistants built out of scrap wood lying around the convent of El Carmen in Seville – a Renaissance building that was found to house his painted Stations of the Cross.

The *Idiota* cross, which stood for a time in the middle of the courtyard of El Carmen – emblazoned with the letters "HDLV" and the name "Manuel Benítez" – was conceived as a kind of battle-standard. Manuel Benítez, for instance, is the name not only of one of the artist's assistants, but also of the great bullfighter El Cordobés. And though "HDLV" stands for "Hotel de la Vida" – an asylum for the sick and suffering – the letters are also very close to those identifying the AIDS virus, and thus perhaps the outstanding symbols of suffering today.

In the series of 1987 map drawings titled "Letter to my Wife" (cat. 58-64), we see Schnabel's early 80s involvement with epic pomp and circumstance carried to new extremes. Yellow and purple paint slash over faint coastlines, suggesting landscapes. Red velvet squares highlight the fading wake left by some miraculous vessel on the ocean. (These effects recall recent tarp paintings in which bits of Baroque *baldequino* float majestically in battered and otherwise impoverished painted fields.) Furthermore, these once pristine charts have been monogrammed with the letters "JB," the intitials of Schnabel's wife, Jacqueline Beaurang. The maps, in fact, are one big monogrammed love letter: "AVG" stands for Jacqueline's middle names (Anne Véra Georgette), and "S," of course, is for Schnabel.

Schnabel's use of lettering and wording in the recent work can also be seen as the most elemental form of drawing – a return to a primitive state in which words and images are no longer separable. His lettering often seems to project a sense of almost talismanic secrecy – as if his paintings contained Eleusinian mysteries impenetrable except to the elect. This goes hand in hand with the customized feeling of funky *grand luxe* that is a constant feature in his work – for instance in the elaborately framed Old Master formats of the recent drawings.

Like a latter-day Watteau, Schnabel seems to be obsessed with the various theatrical settings for "l'amour" – and may even be concocting new "fêtes galantes." A 1987-88 series of large drawings (cat. 65-71) offers specific examples of French *galant* iconography, in the form of vintage prints floating around in fields of pristine white paper. In the *Confused Girl* (cat. 68) of 1988, on old Greuze print – *La fille confuse* – has been subjected to a welter of purple and black phallic shapes. Another palatial collage, *Lost Innocence* (cat. 69), makes use of an old Prudhon print, while the disembodied letters of the title – "NNO," "CE" – float through a mask of paint, like the Lucullan remnants of some unfathomable Roman date.

Schnabel is of course still making broken-plate paintings – "plein air" portraits, to be precise, of his family and friends – that confirm the fundamentally domestic scale and emotion of his work. Only now his idea of household approaches that of royal retinue. Schnabel's stated desire was "to bring back the figure without all of the colloquial hangups of drawing a face," but his bold break-up of the picture-plane has resulted in the fragmentation of language, authorship, and historical time. A decade that began with broken plates now ends with broken words; and one that began with homages to old Romantic images seems to be culminating in a new, compound-complex Romantic genre.

NOTES

1 These concrete-poem paintings are part of a new group, the Bordeaux Cycle, that is discussed in my article "'I Hate to Think,' The New Paintings of Julian Schnabel," *Parkett* 18, December 1988, pp. 110-22.
2 *The New Yorker*, March 13, 1989, p. 23.
3 All quotes from the artist are from conversations with the author in March-April 1989.
4 For an extended comparison between Ensor and Schnabel, see my "Ensor as a 1980s Artist," *Print Collector's Newsletter* 19/1, March-April 1988, pp. 10-12.

1 *Untitled*, 1975

2 *Untitled*, 1976/77

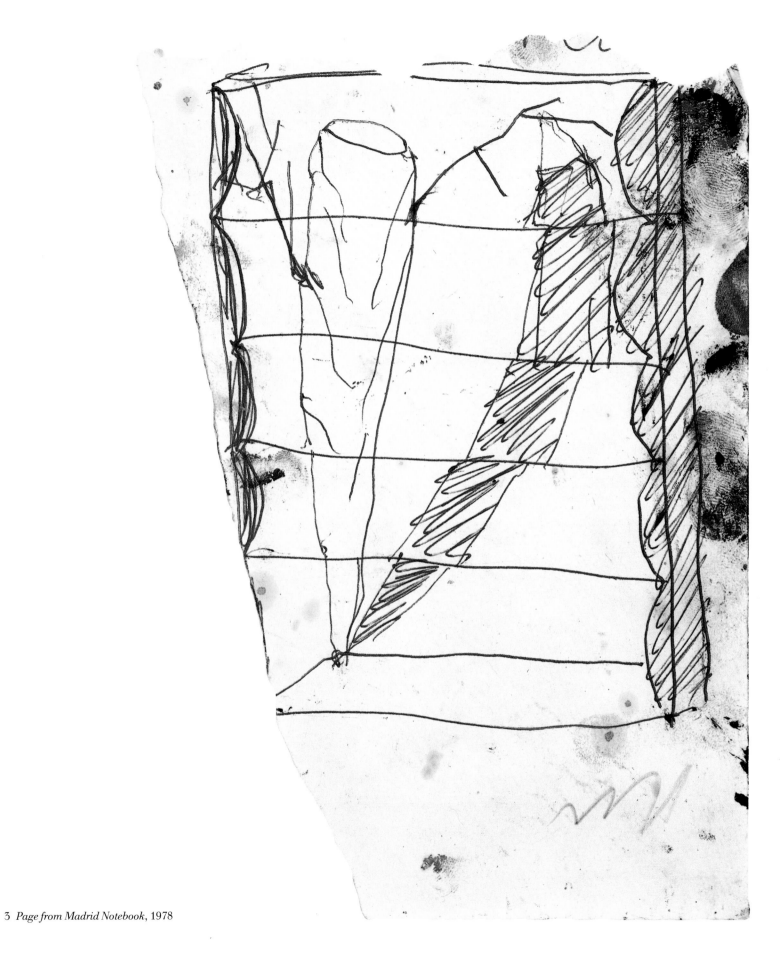

3 *Page from Madrid Notebook*, 1978

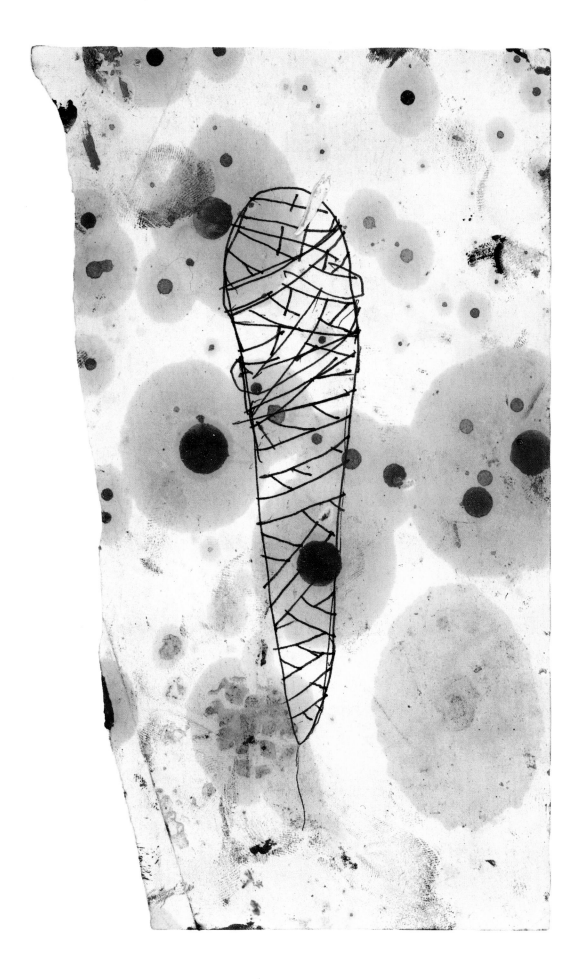

4 *Page from Madrid Notebook*, 1978

5 *Drawing for 'What to Do with a Corner in Madrid'*, 1978

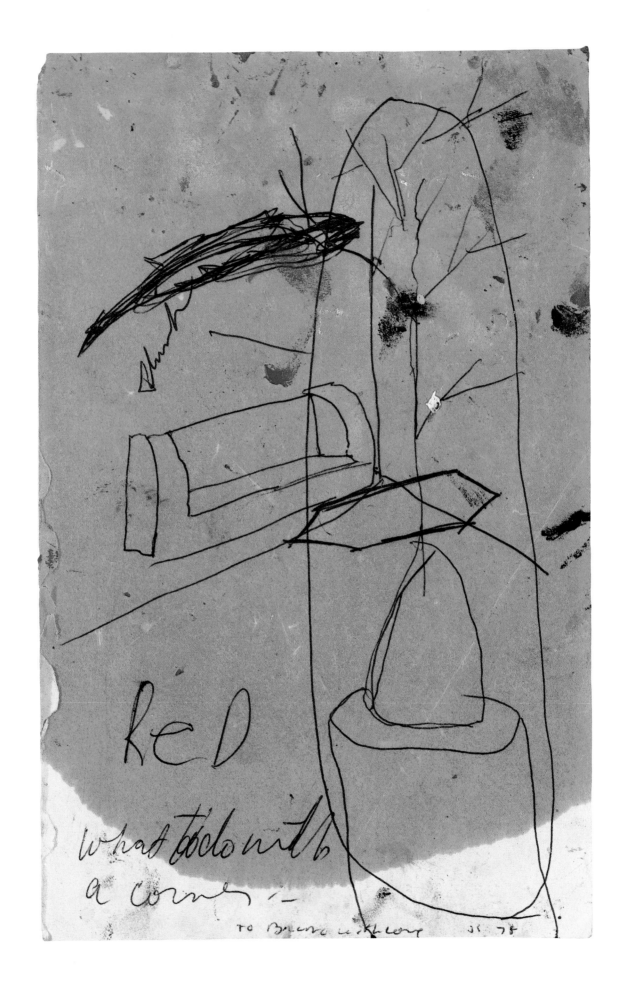

ReD

what to do with
a corner –

to Bruno with love JS 78

6 *Page from Madrid Notebook*, 1978

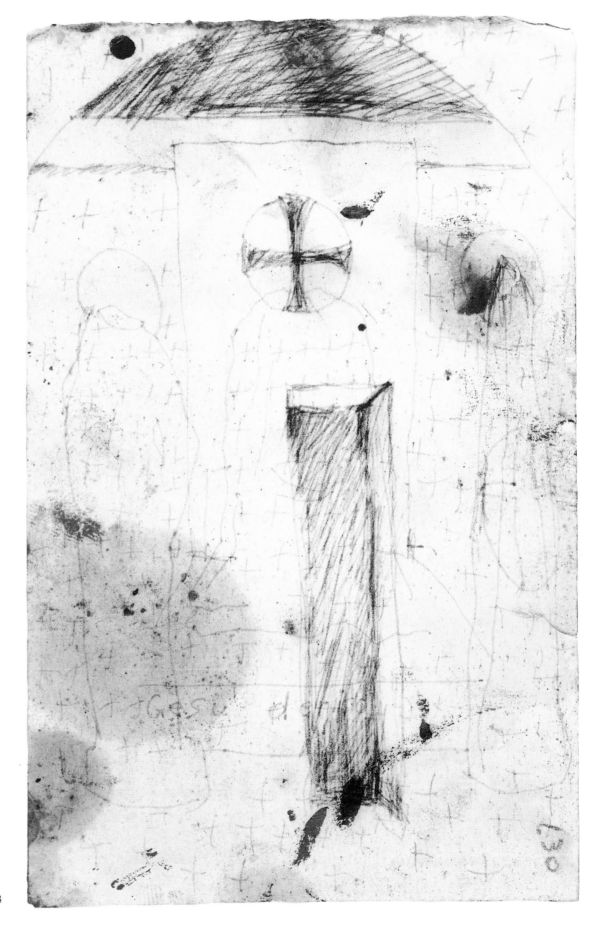

7 *Page from Madrid Notebook*, 1978

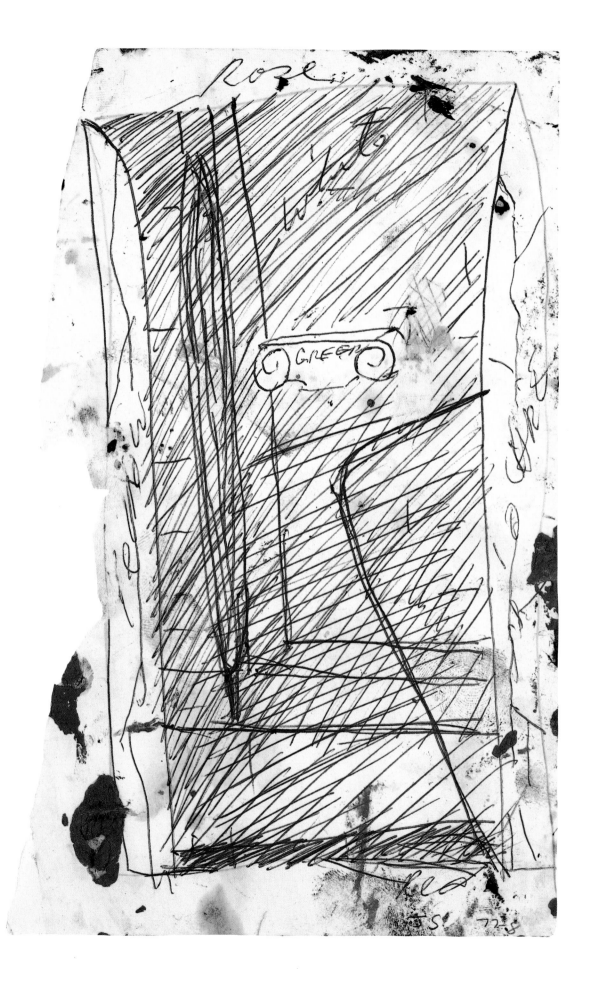

8 *Untitled*, 1978

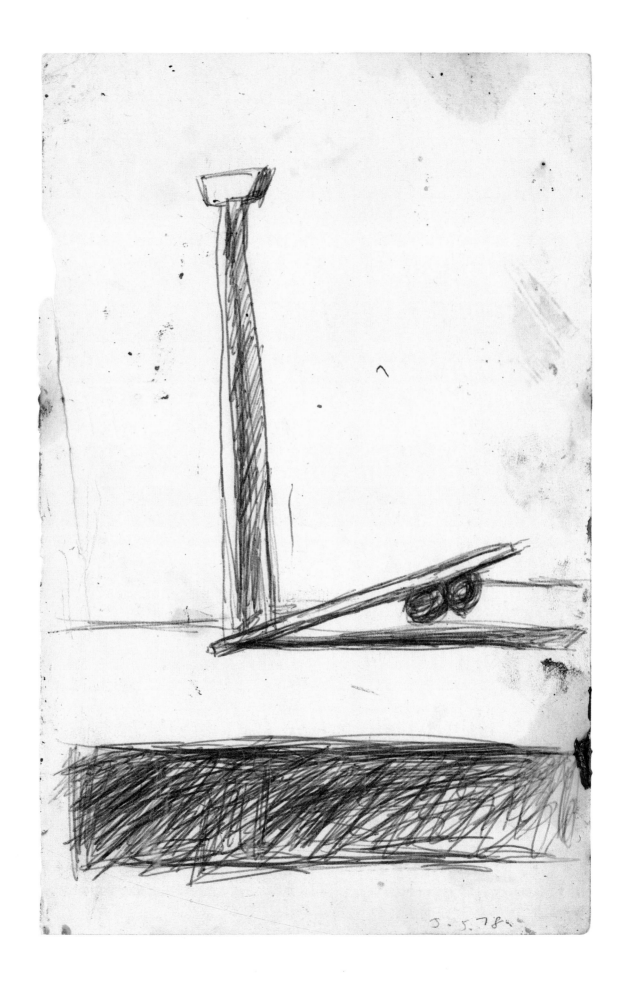

9 *Untitled*, 1978

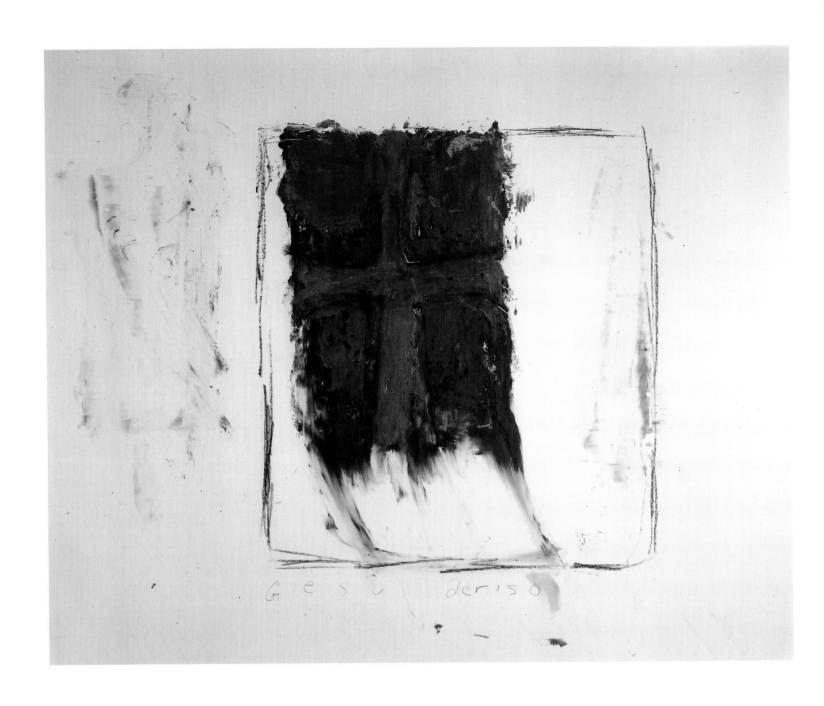

10 *Gesù Deriso*, 1978

11 *The Rhine, Page from German Notebook*, 1978

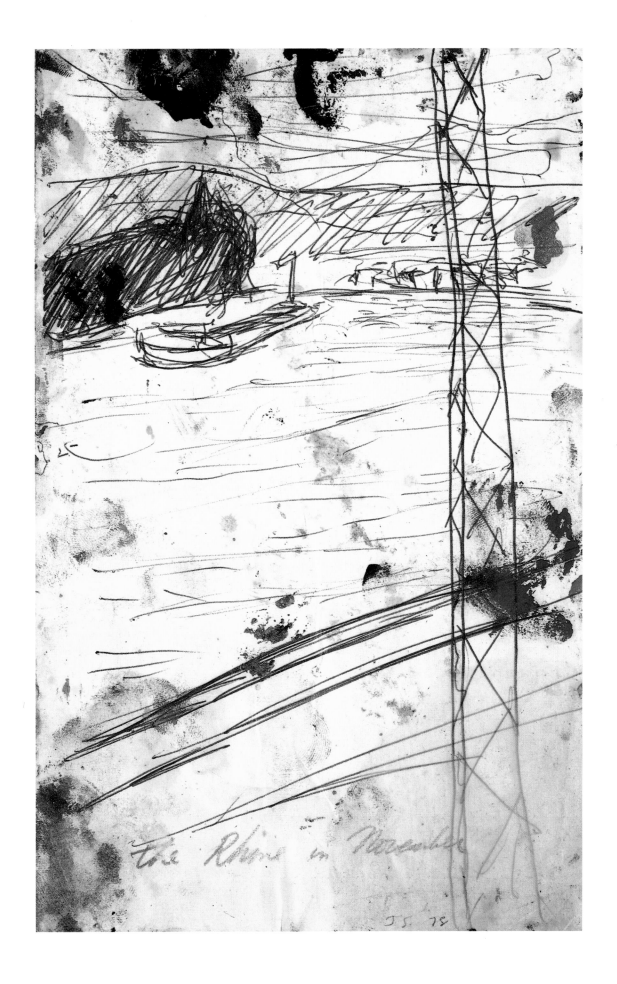

the Rhine in November

J S 78

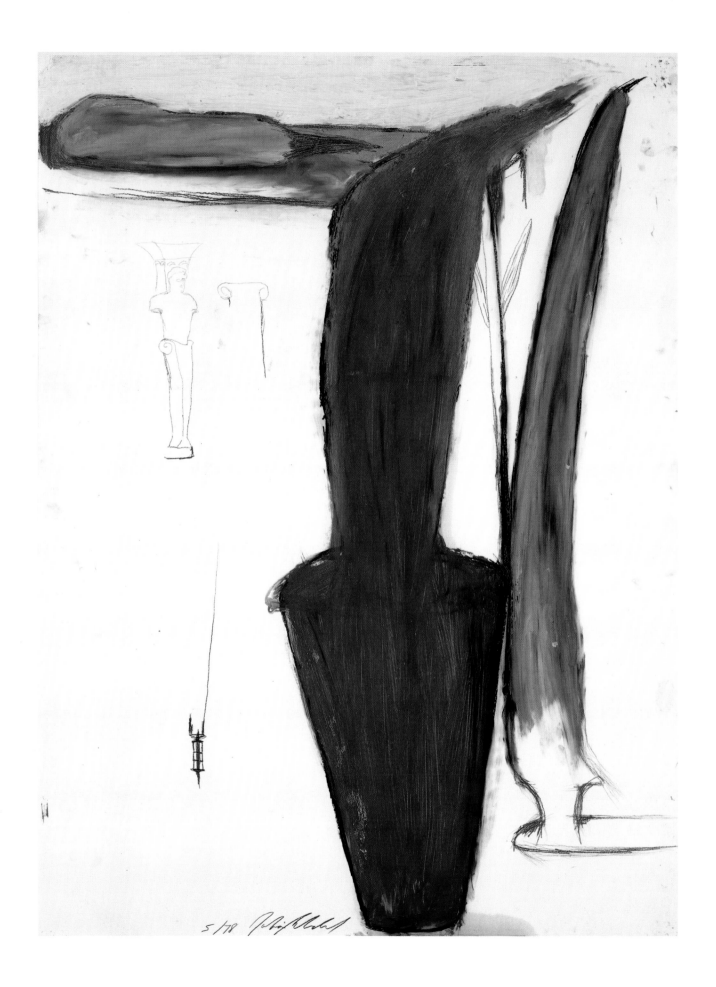

5/78

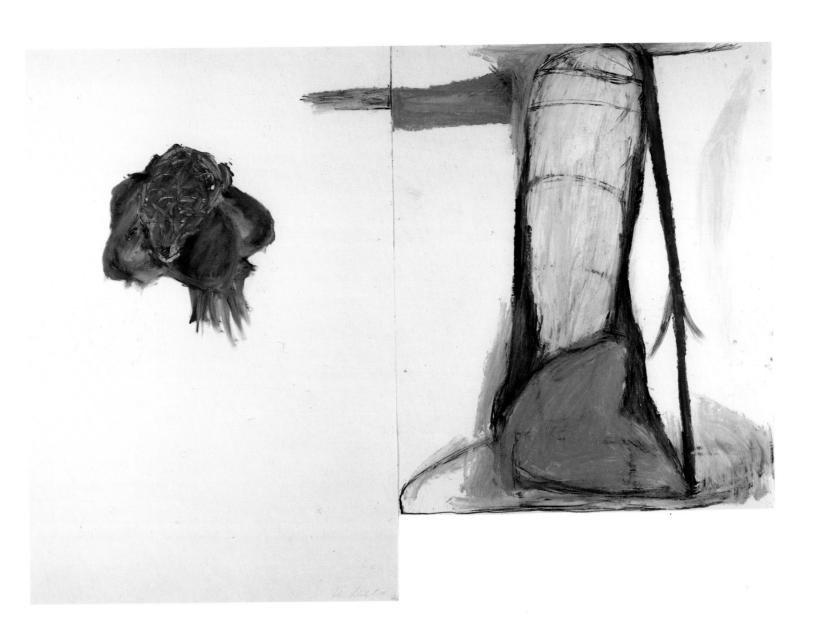

12 *Untitled Drawing for Aldo Moro*, 1978 13 *Joan of Arc*, 1978/79

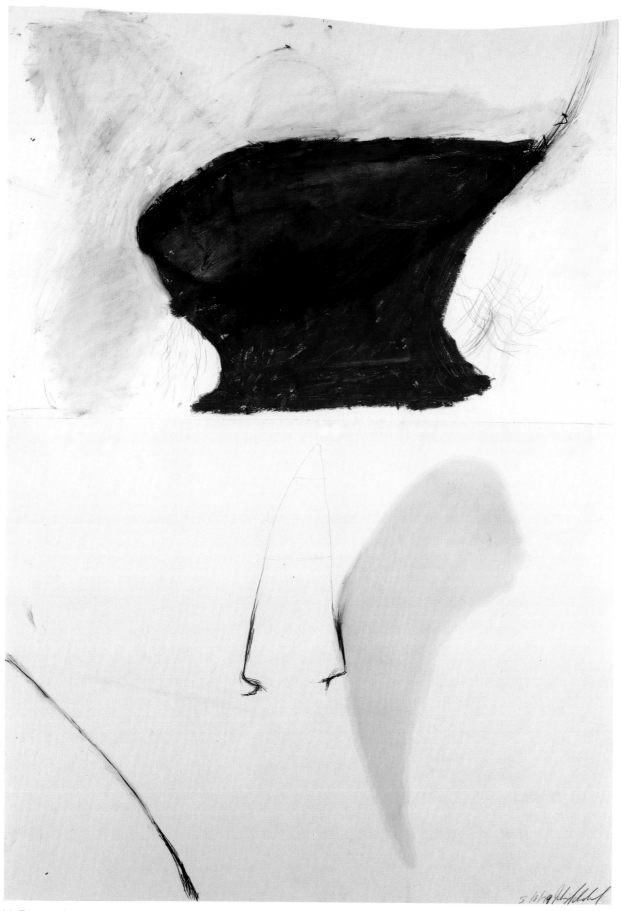

14 *Drawing for Albrecht Dürer*, 1979

15 *Accattone*, 1979

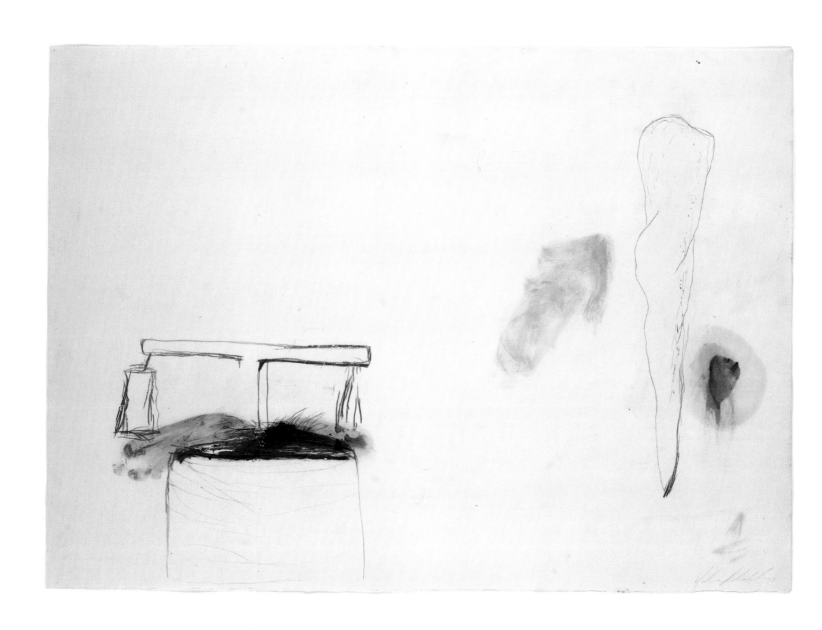

16 *Untitled Drawing*, 1979

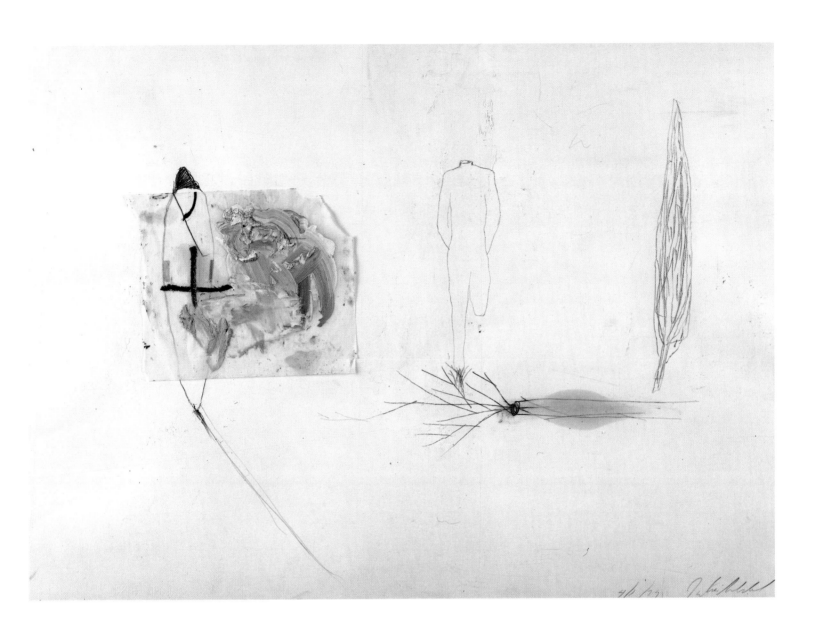

17 *Second Drawing for Aldo Moro*, 1979

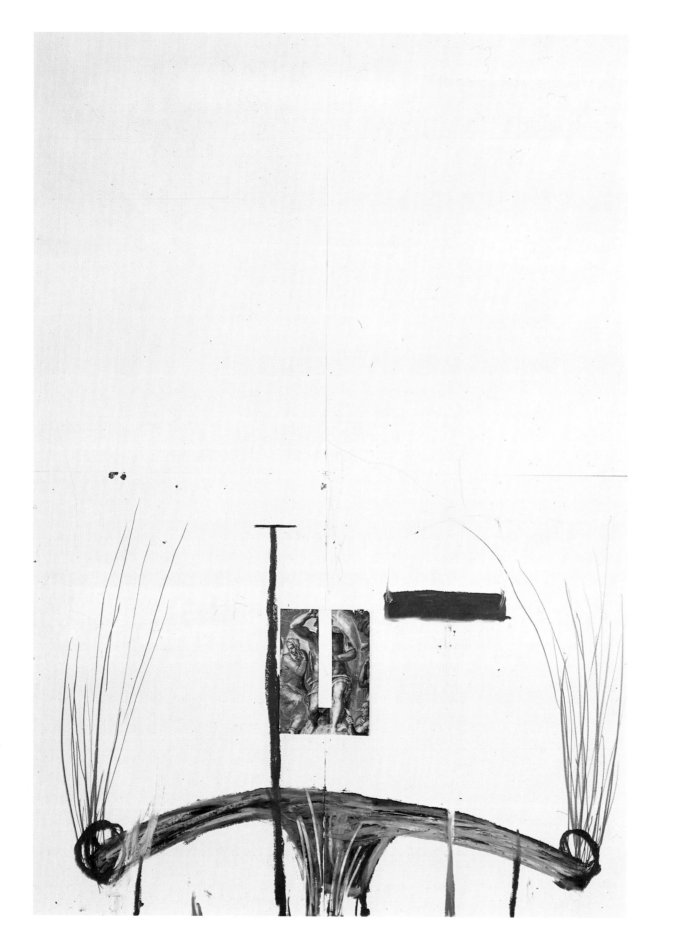

18 *Untitled*, 1979

19 *The Conversion of St. Paul*, 1979

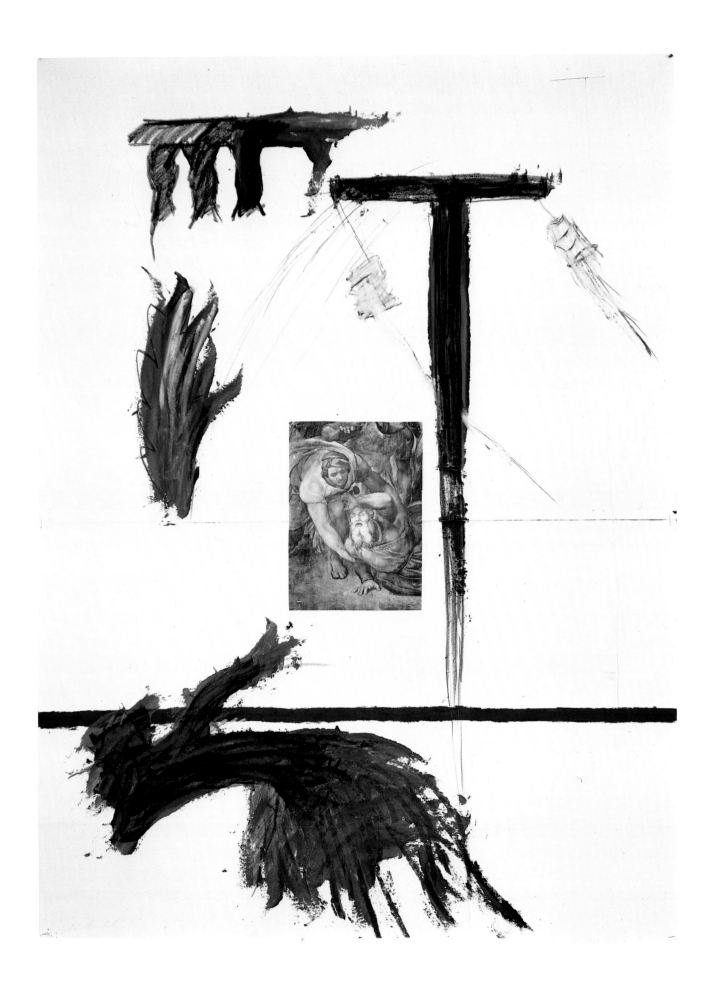

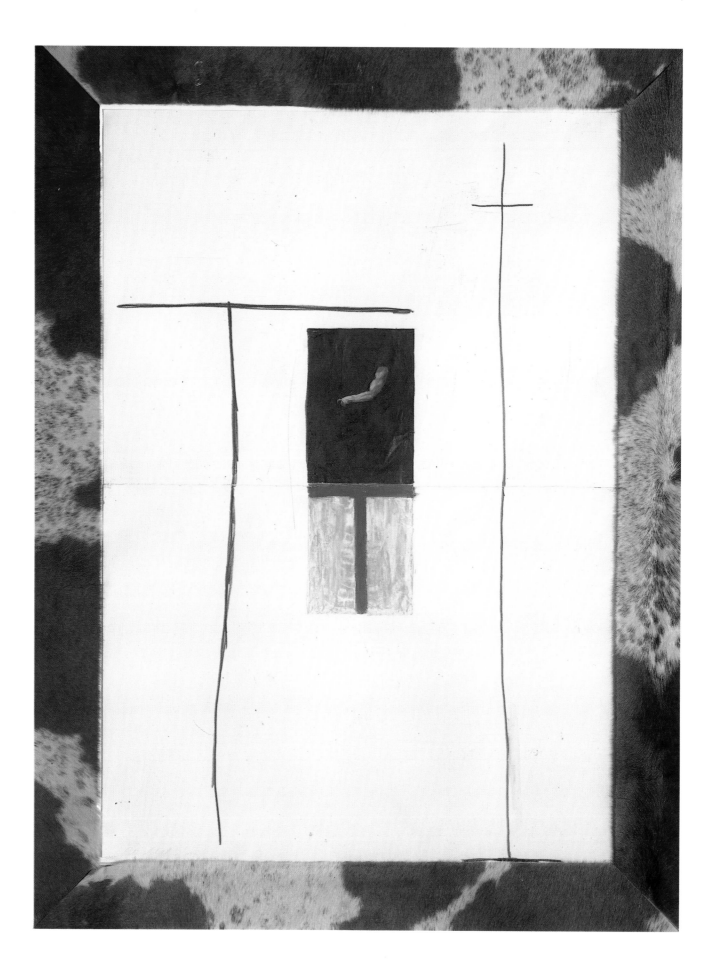

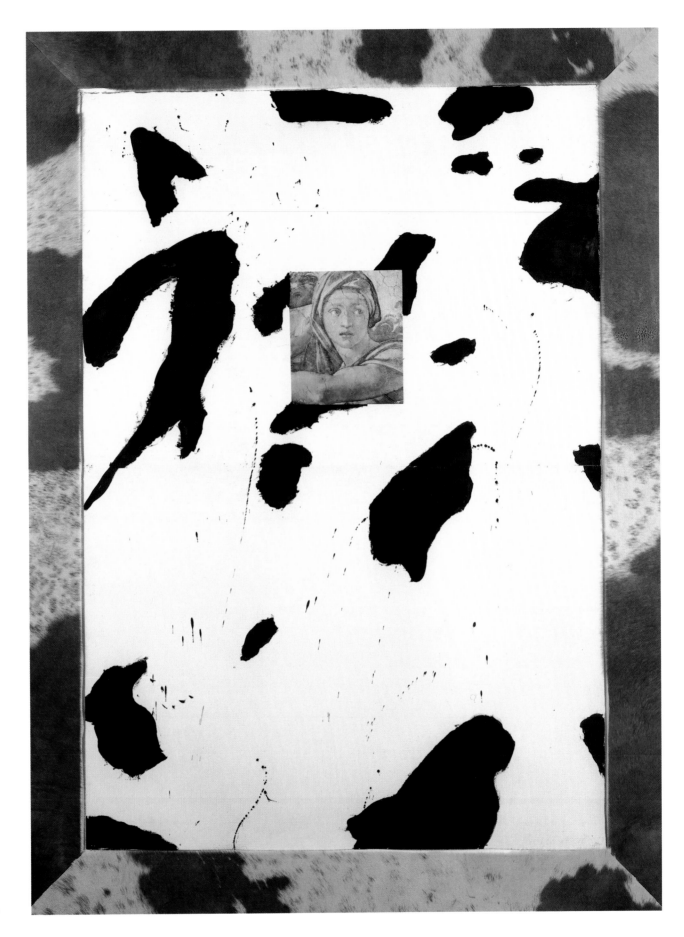

20 *Arm*, 1979

21 *Untitled*, 1979

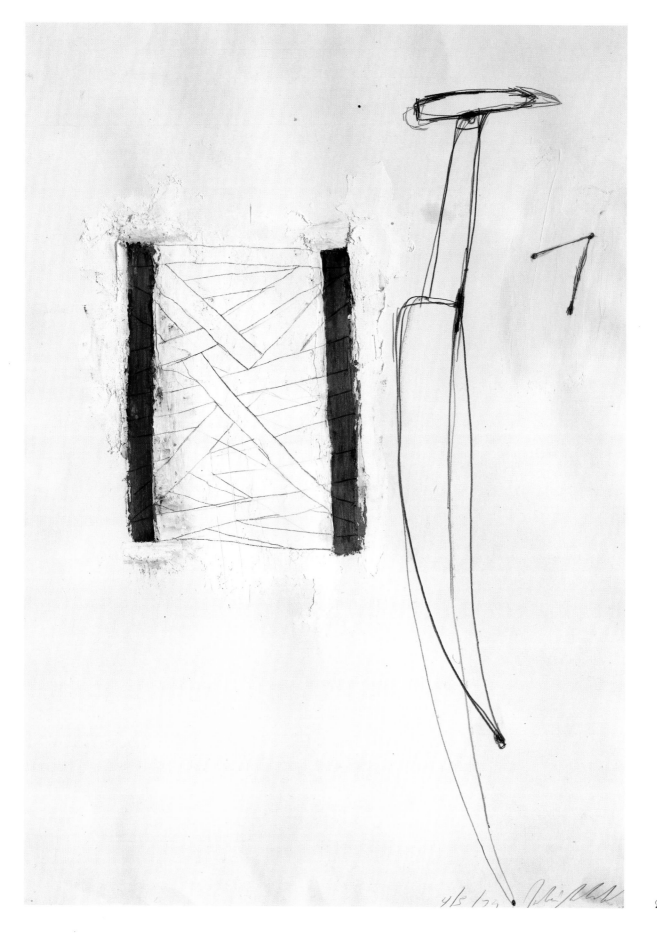

4/5/79

22 *Blinky and Imi*, 1979

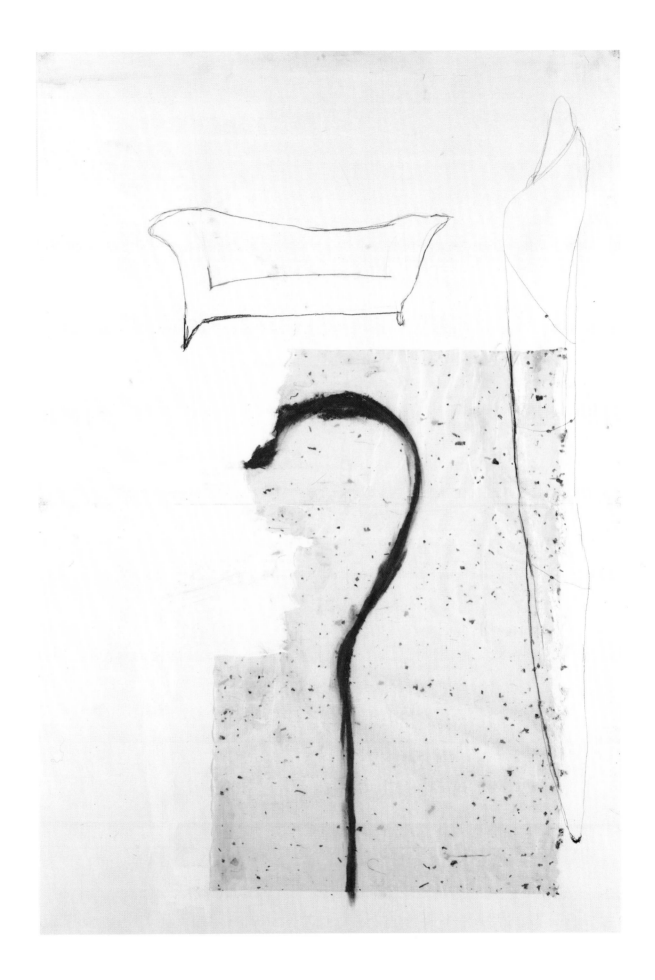

23 *Untitled (Divan)*, 1979

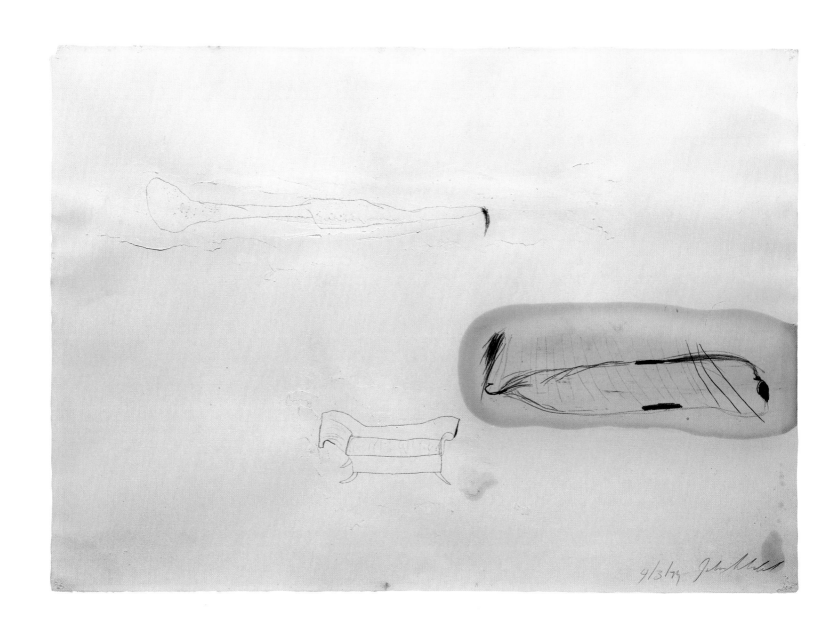

24 *Untitled*, 1979

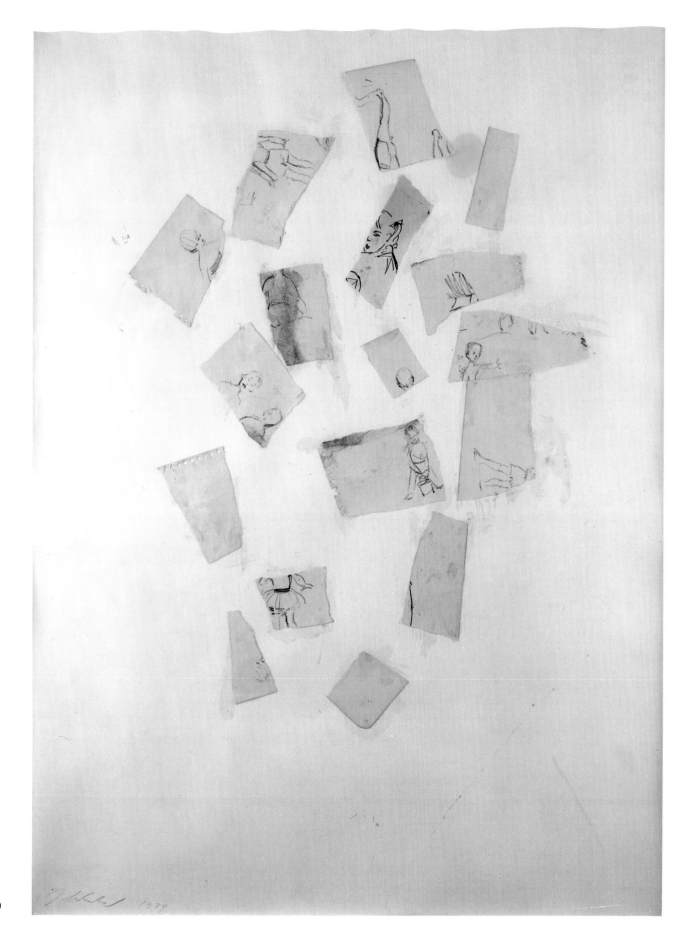

25 *Untitled*, 1979

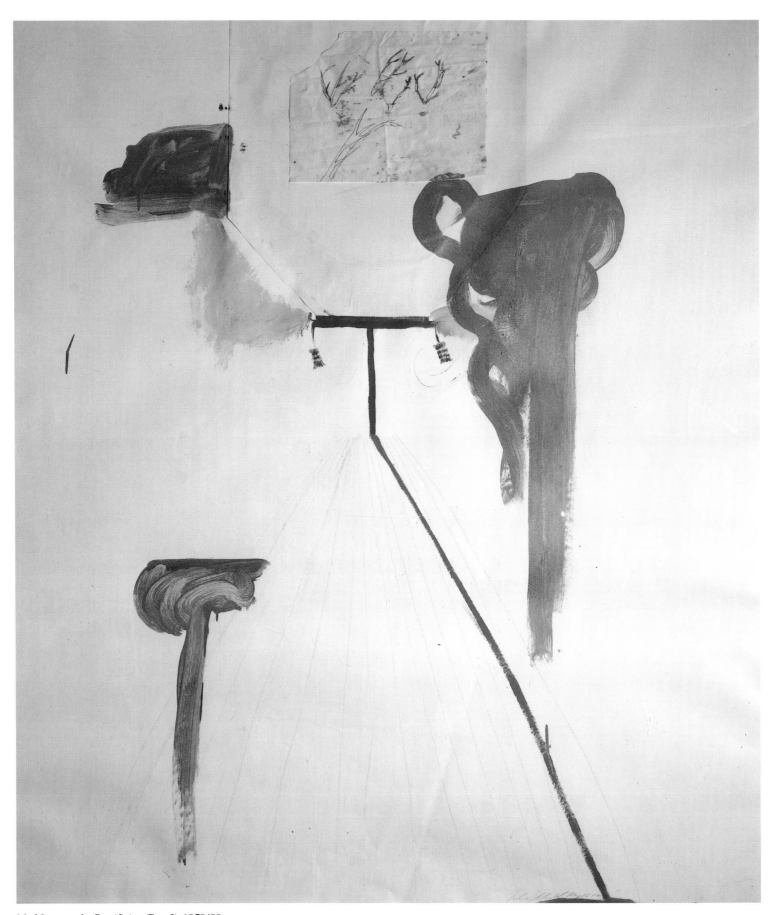

26 *Memory of a Crucifixion (Part 2)*, 1979/80

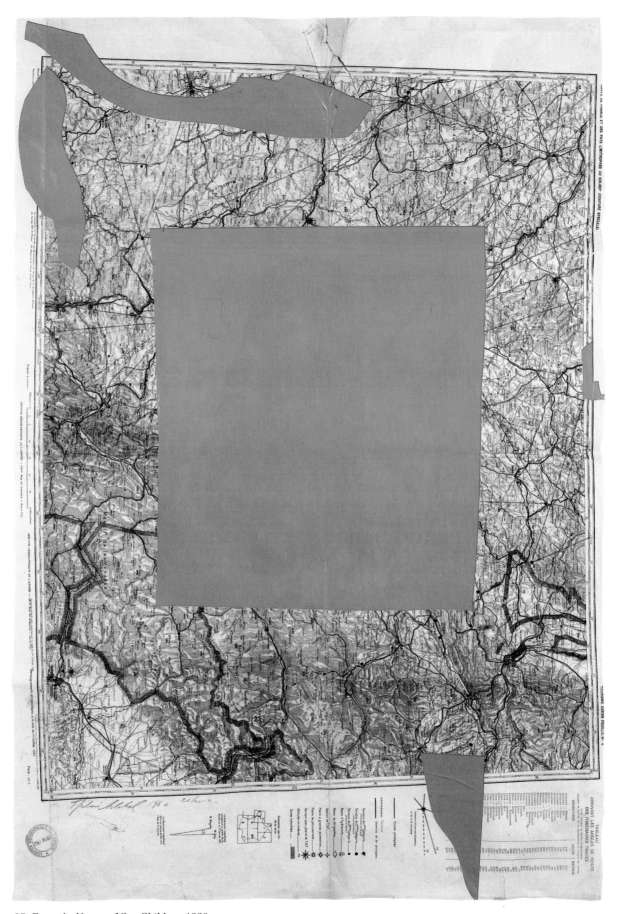

27 *From the Names of Our Children*, 1980

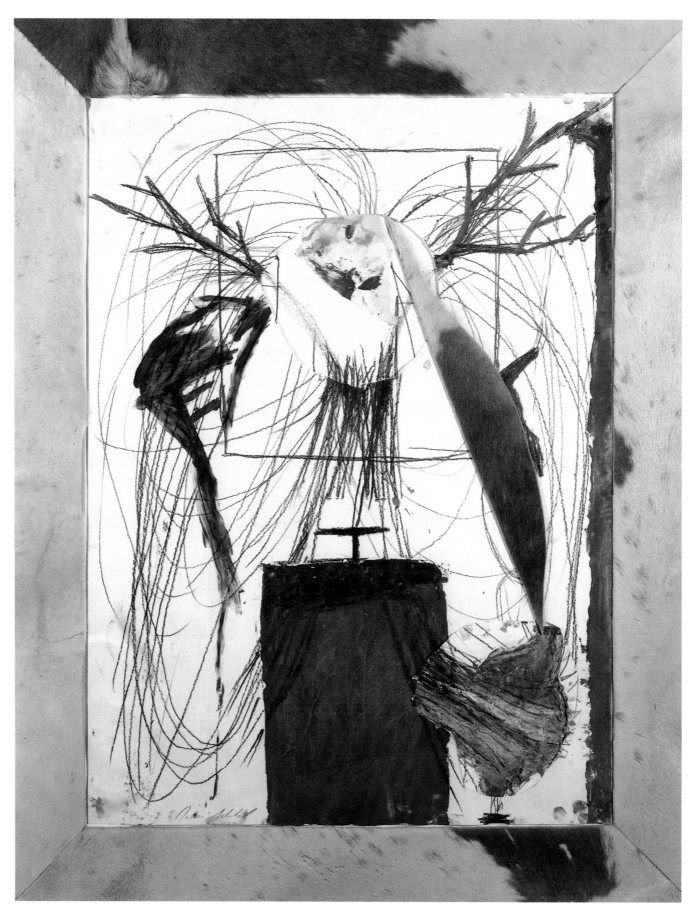

28 *Dead Drawing*, 1980

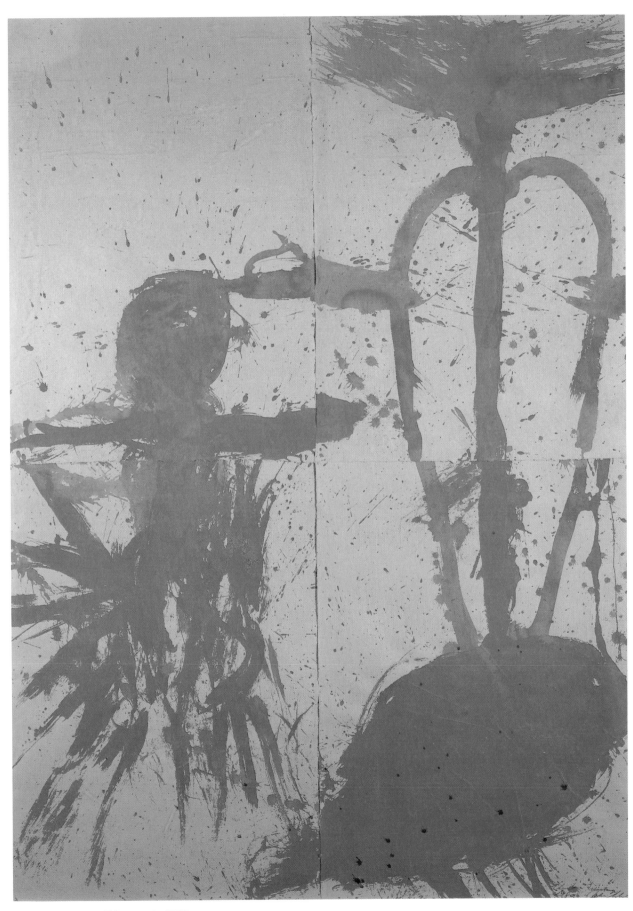

29 *Christ Entering Zihuatanejo*, 1980

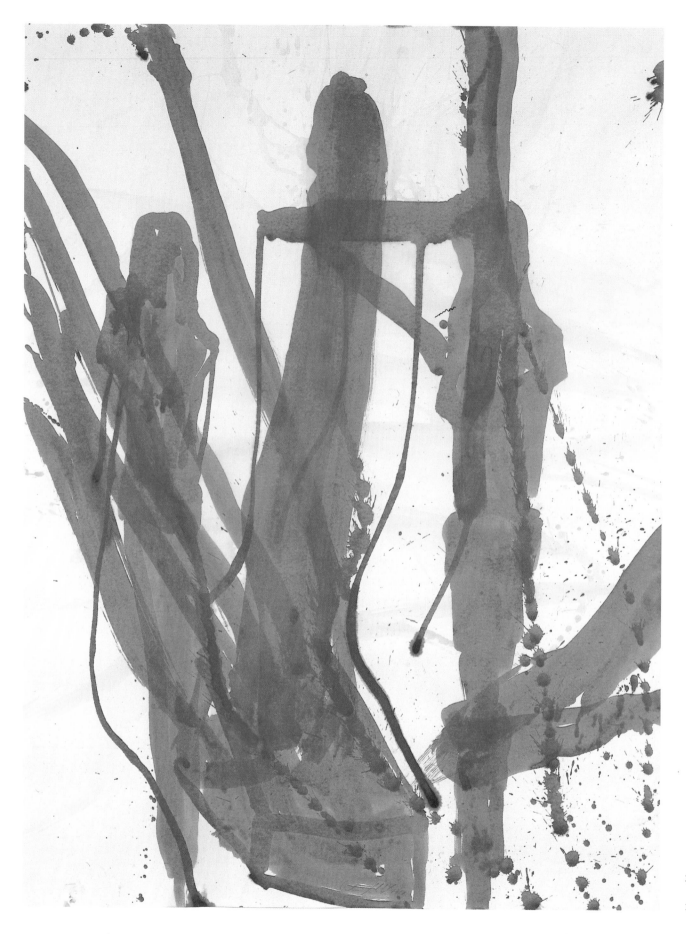

30 *Untitled*, 1981

31 *Untitled*, 1981

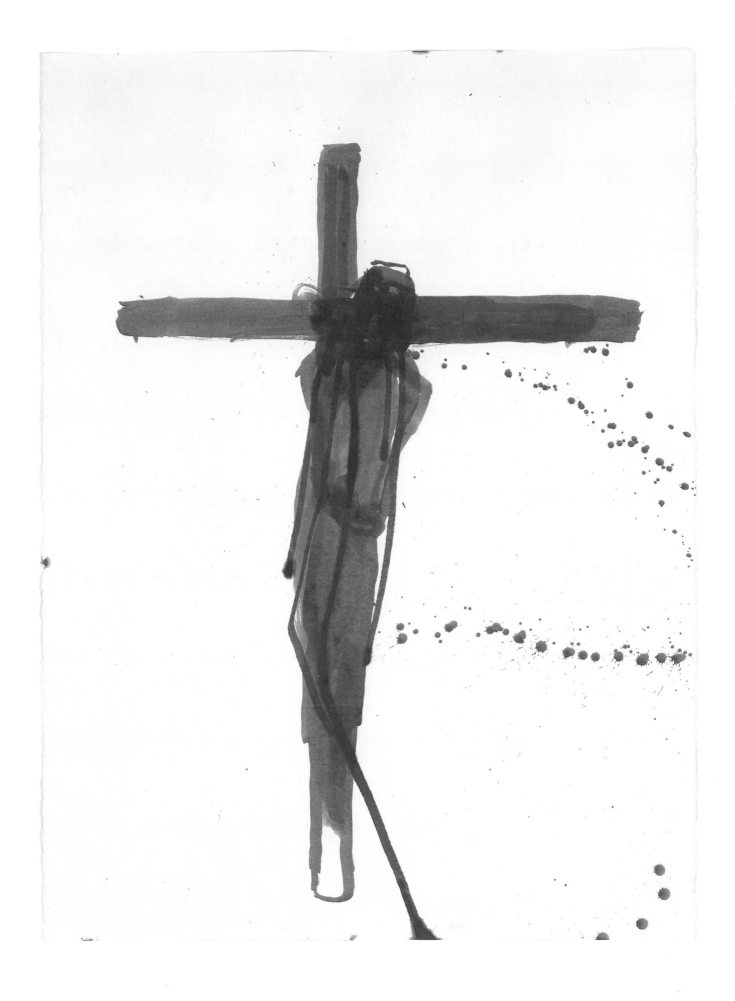

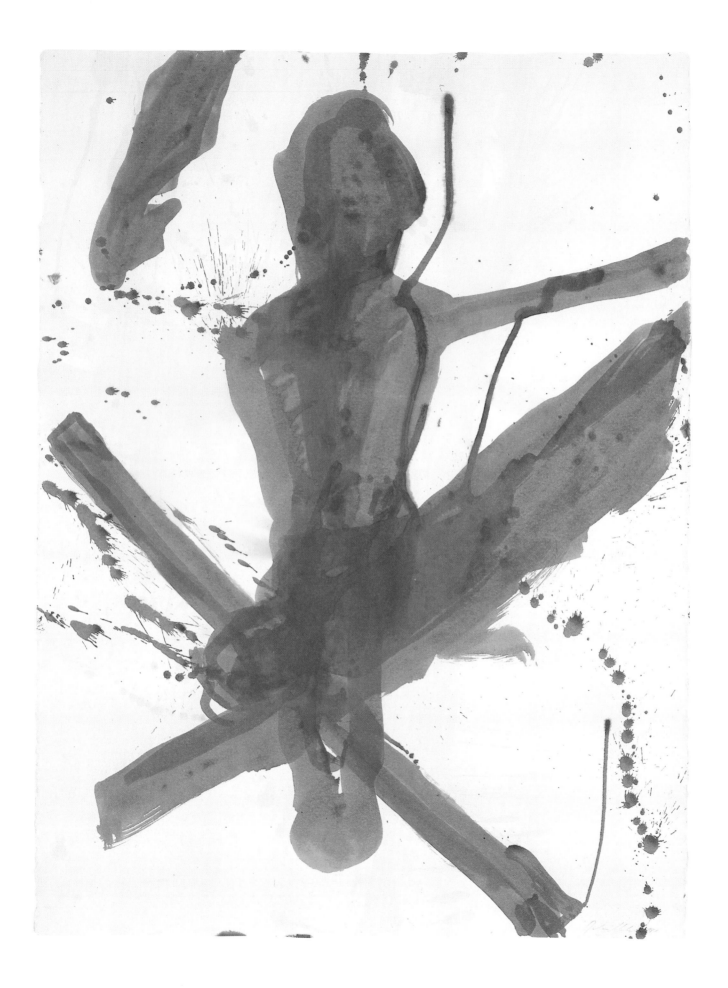

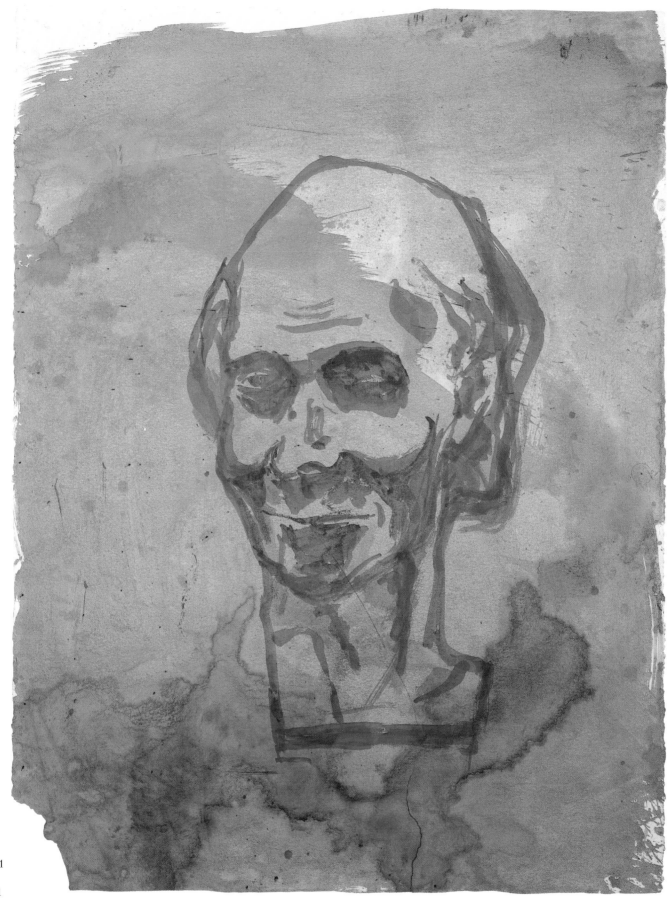

32 *Untitled*, 1981

33 *Voltaire*, 1981

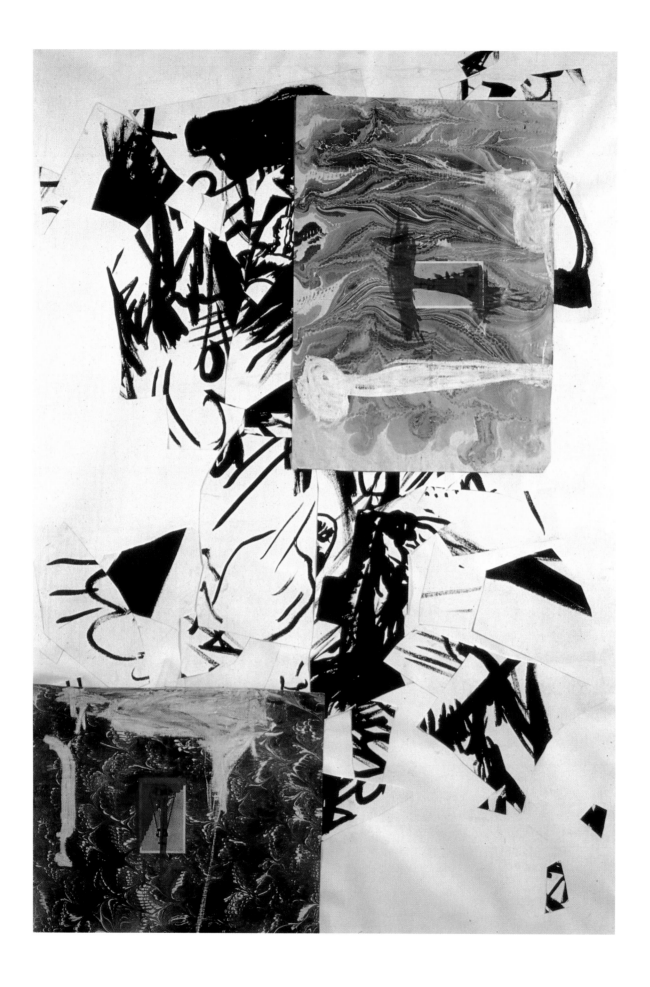

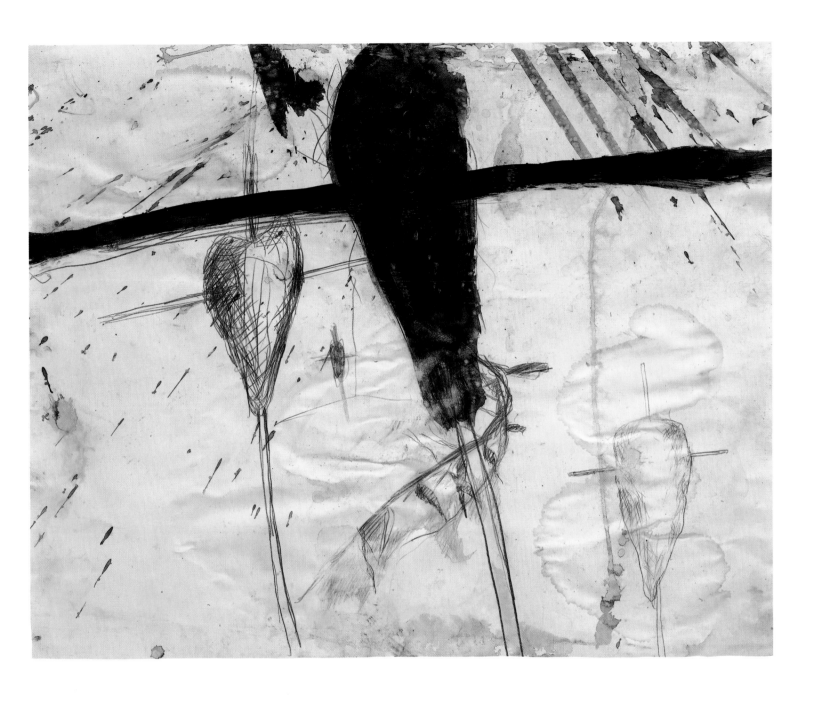

34 *Untitled*, 1981

35 *Drawing in the Rain, Pomme de Terre*, 1981

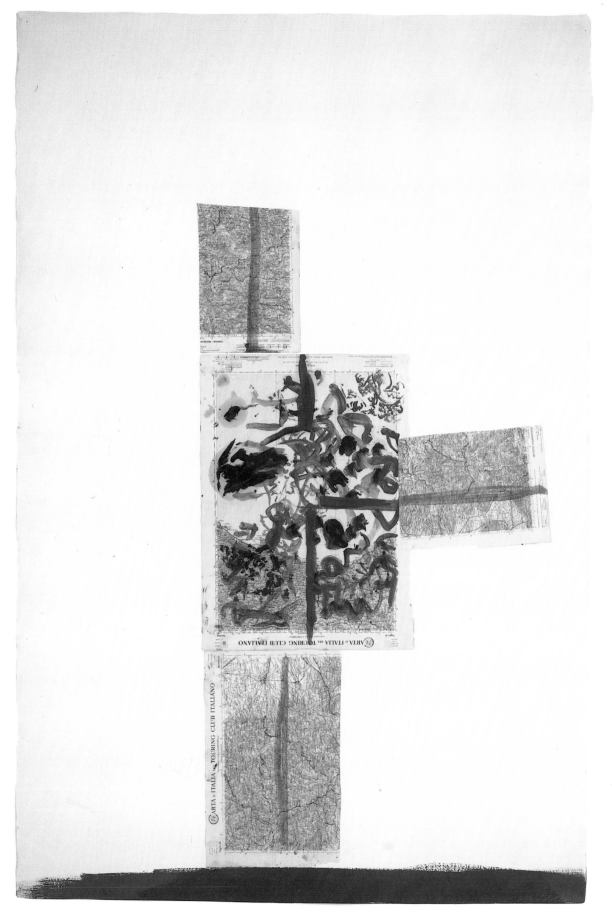

36 *For a Bunch of Grapes*, 1981

37 *Untitled*, 1981

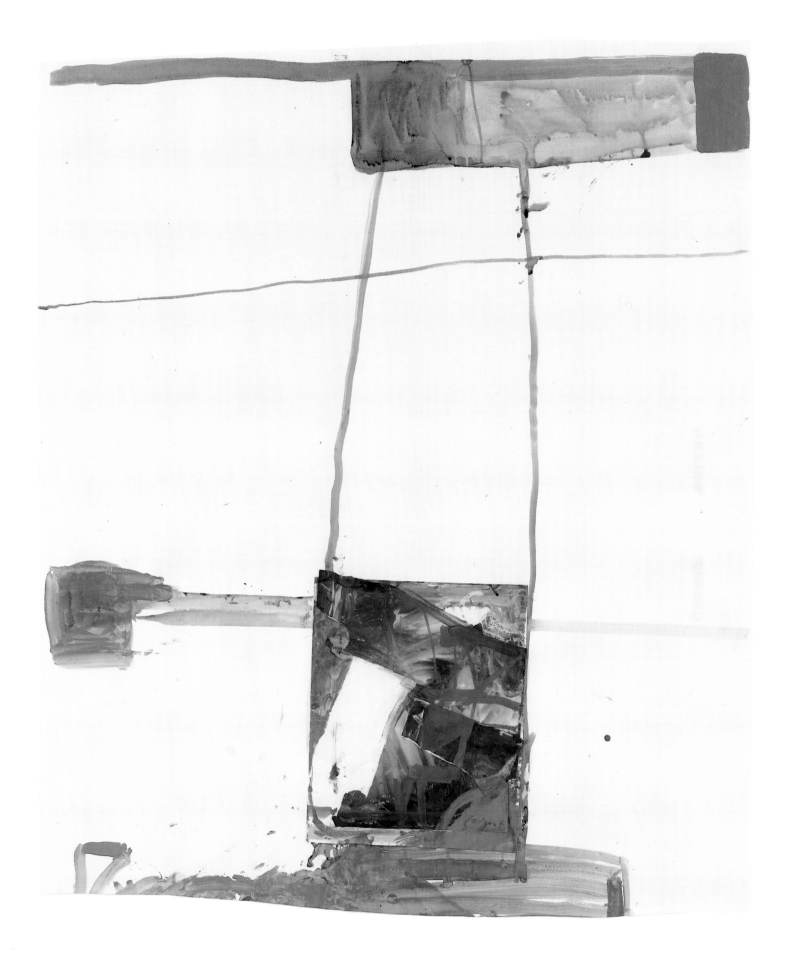

38 *Drawing for Sculpture*, 1982

39 *Death of an Ant Near a Powerplant
 in the Country*, 1982

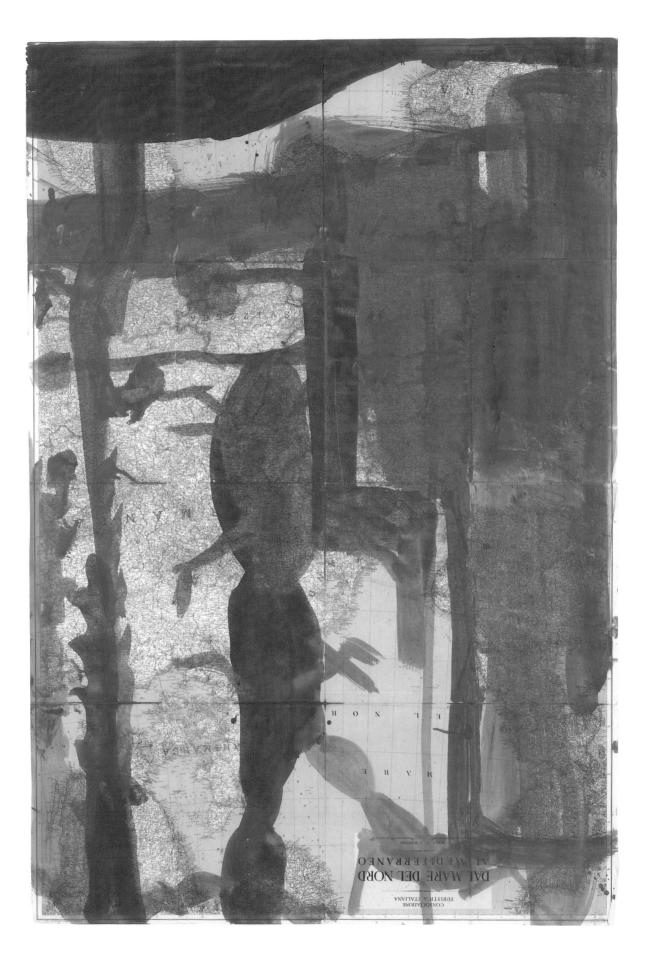

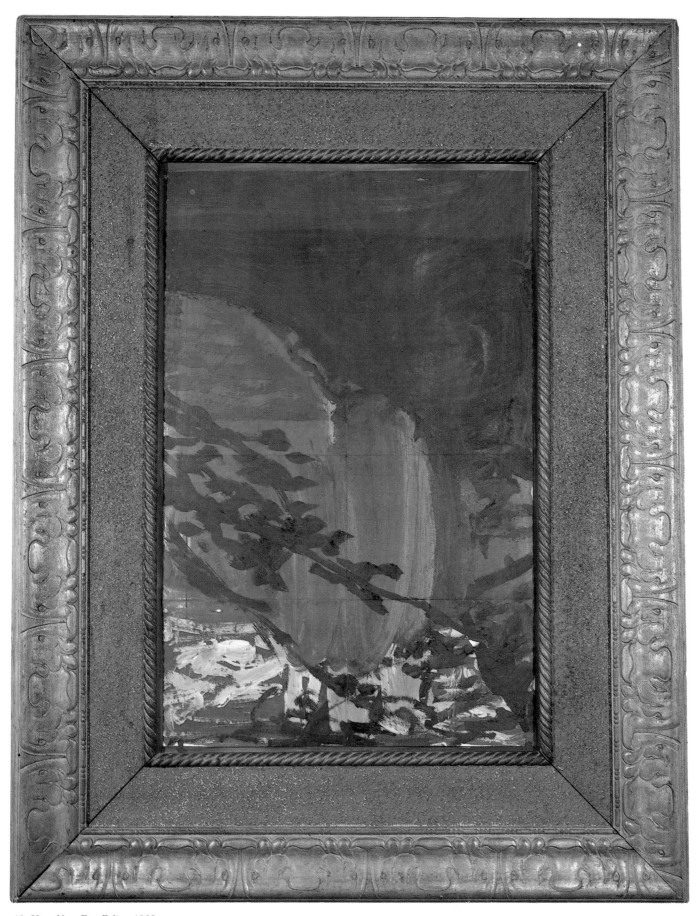

40 *View Near Fort Felipe*, 1982

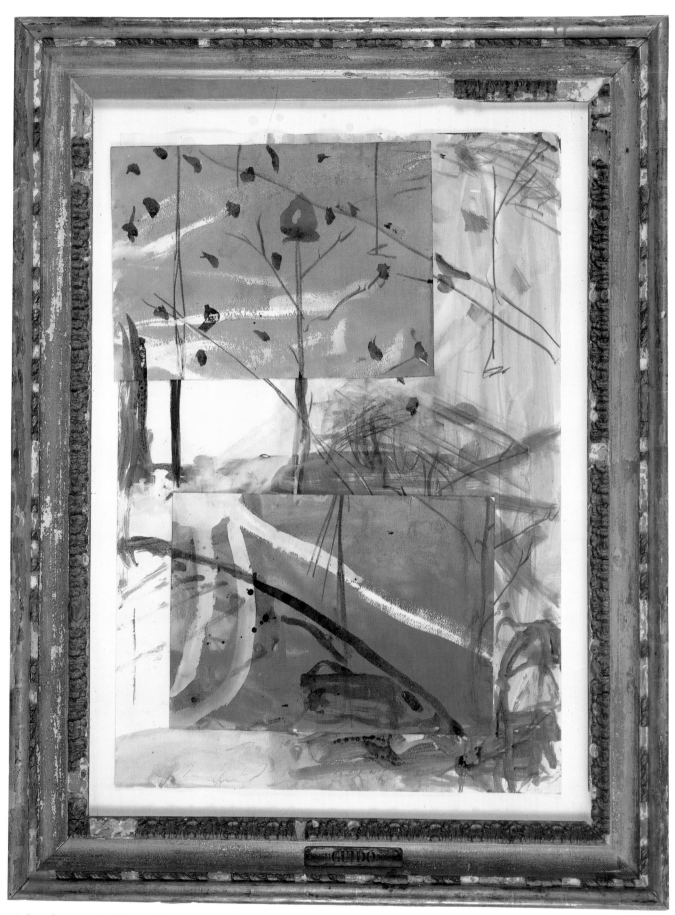

41 *Rose Garden in the Winter*, 1982

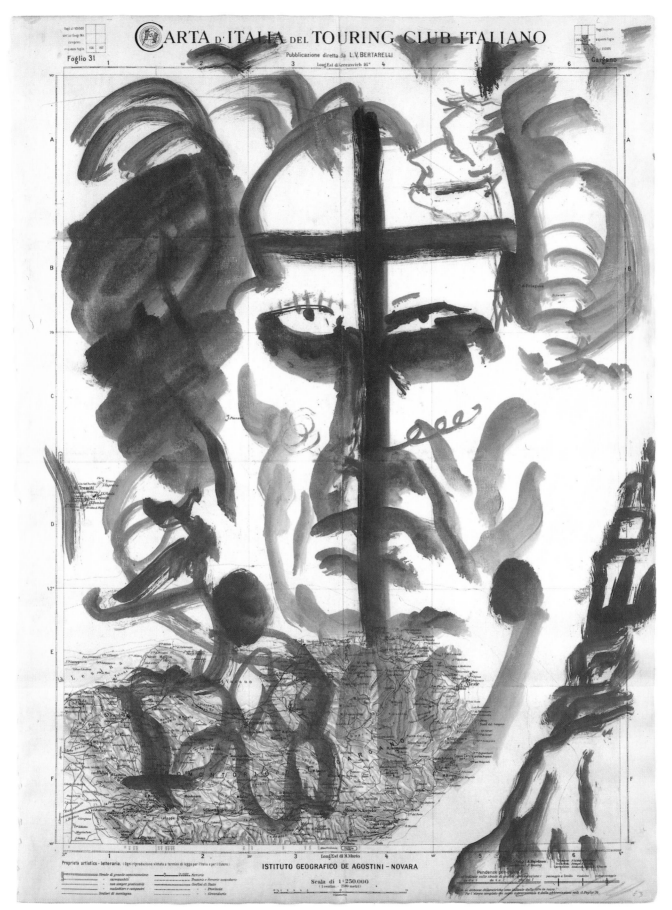

42 *Untitled*, 1983

43 *Untitled*, 1983

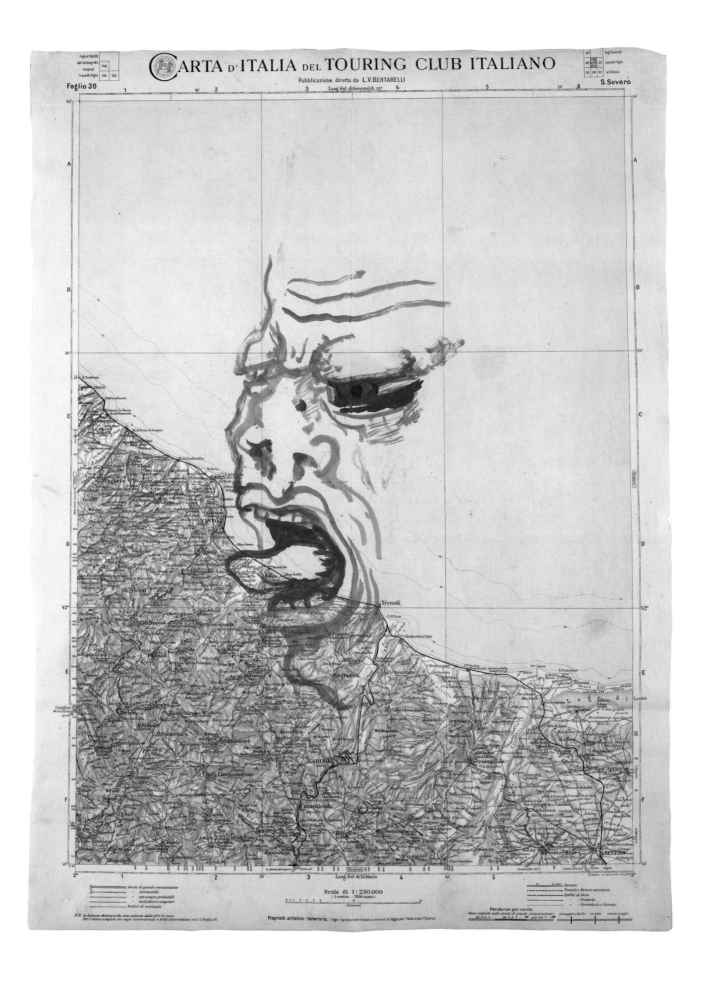

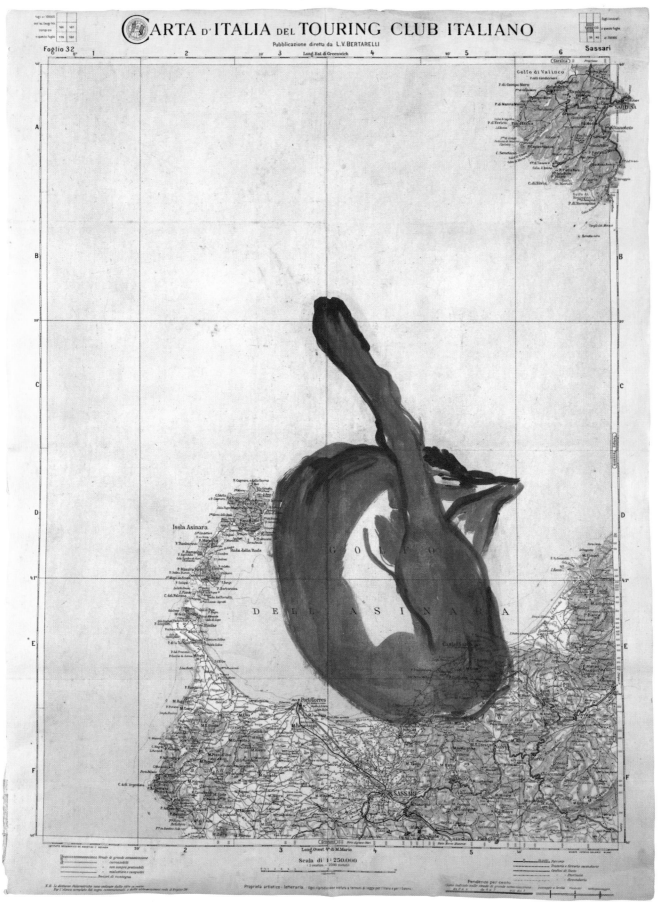

44 *Untitled*, 1983

45 *Untitled*, 1983

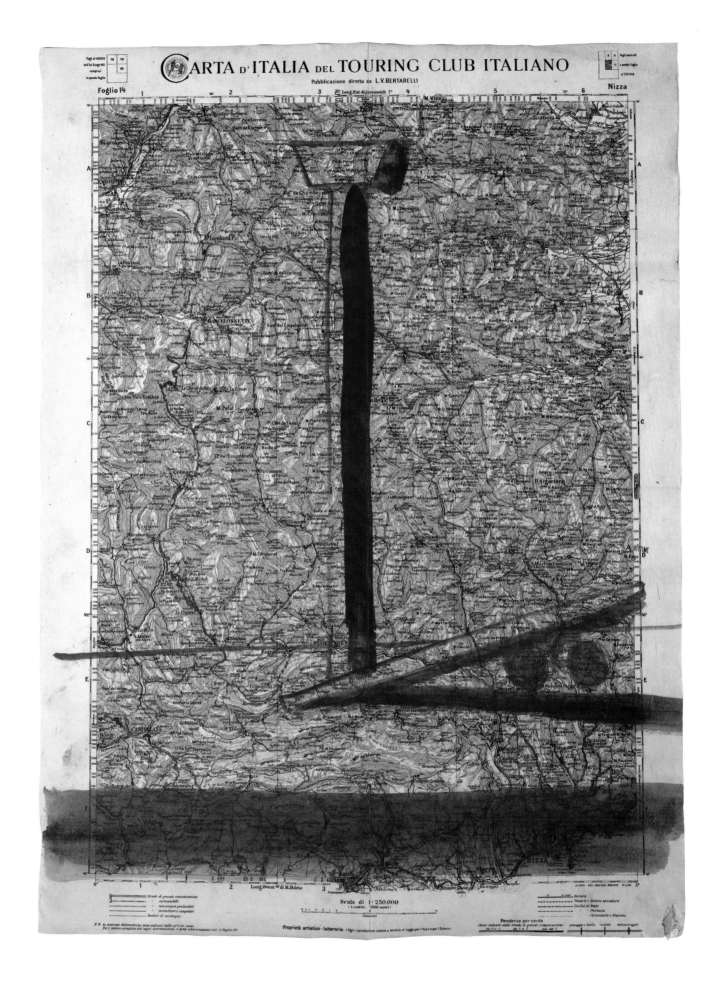

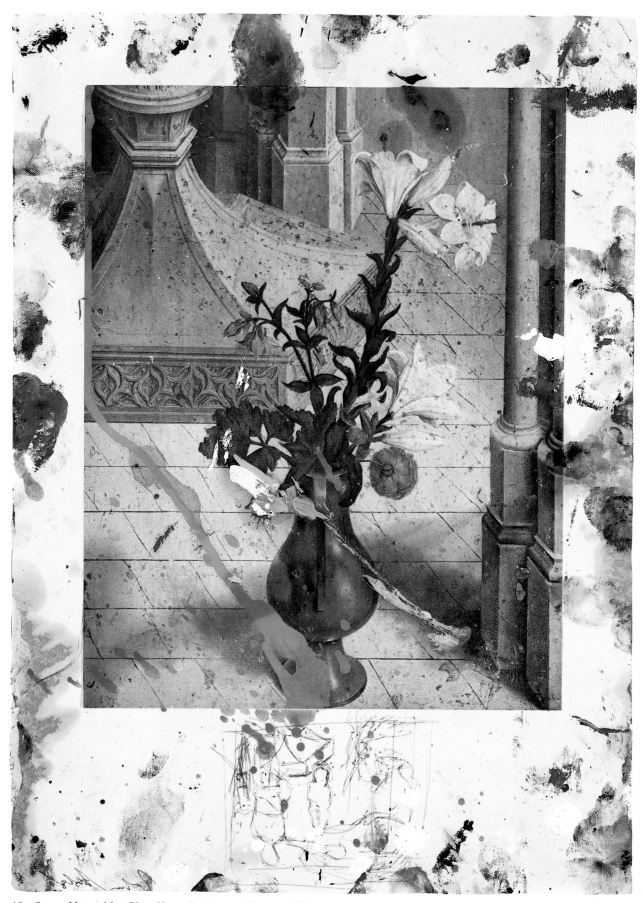

46a *Source Material for: Glory, Honor, Privilege and Poverty, 1983*

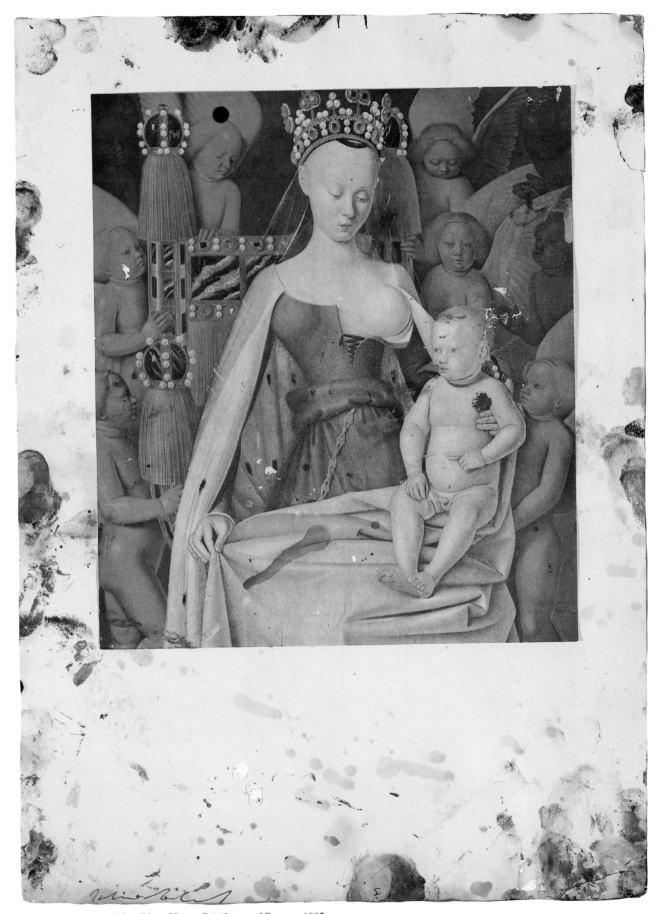

46b *Source Material for: Glory, Honor, Privilege and Poverty*, 1983

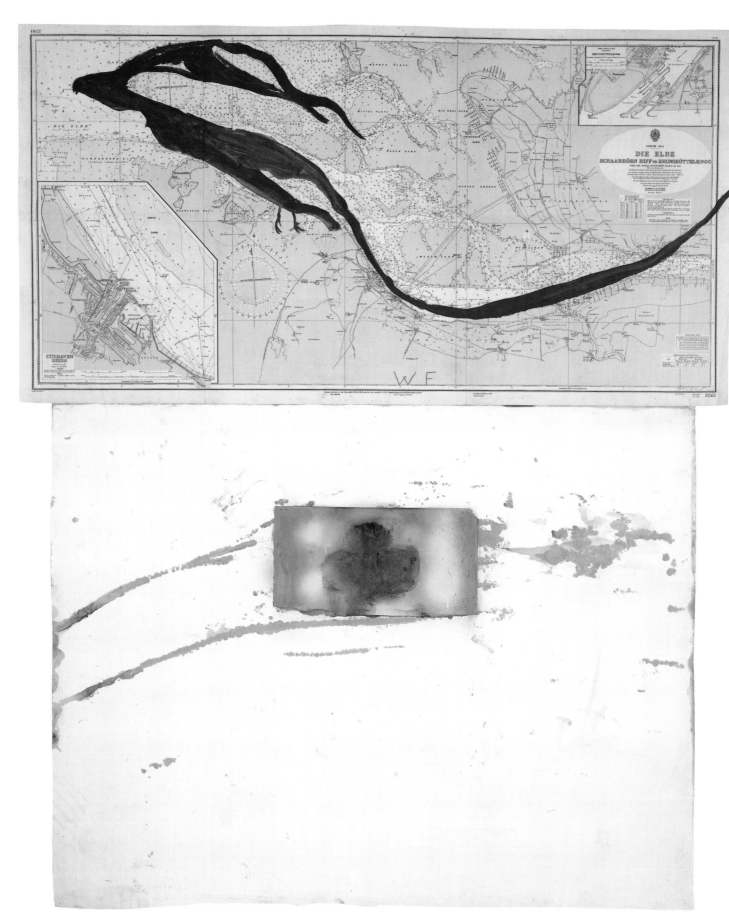

47 *Die Elbe*, 1985

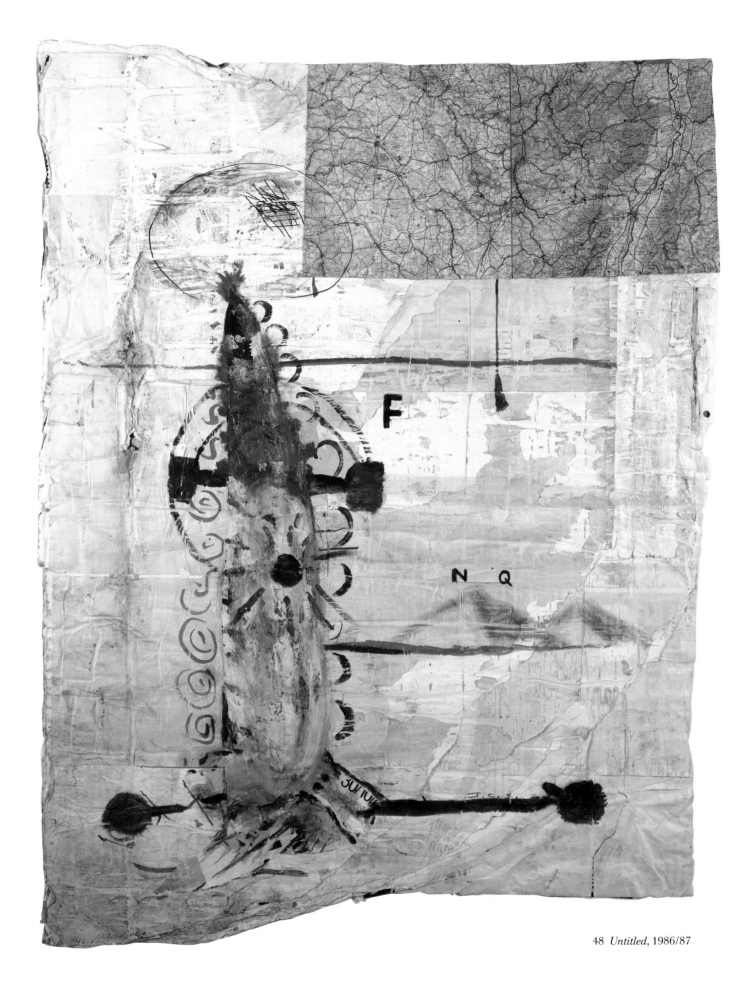

48 *Untitled*, 1986/87

49 *Untitled Purple Drawing II*, 1987

50 *Untitled Purple Drawing IV*, 1987

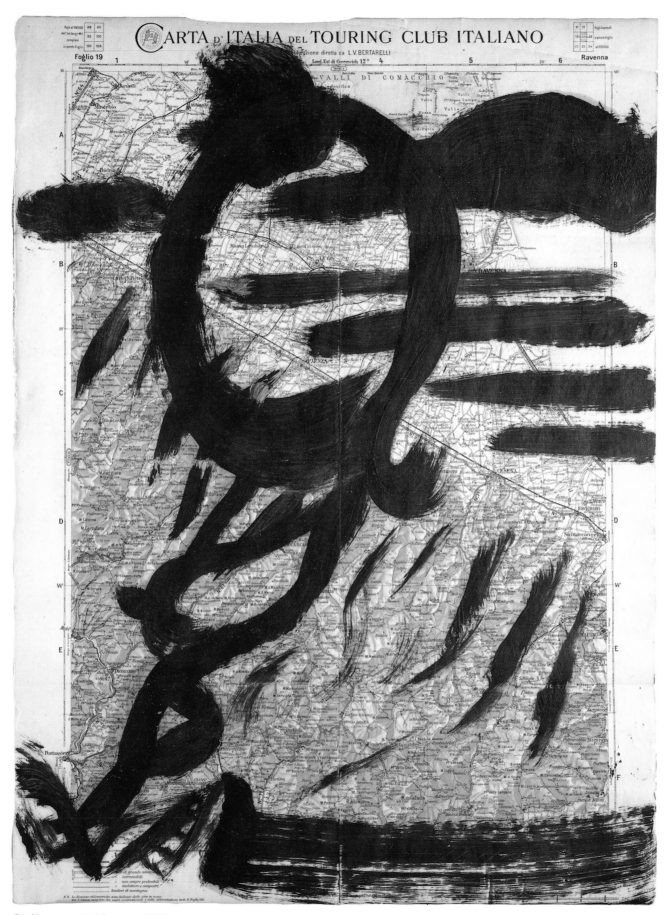

51 *Notes on a Bad Summer*, 1987

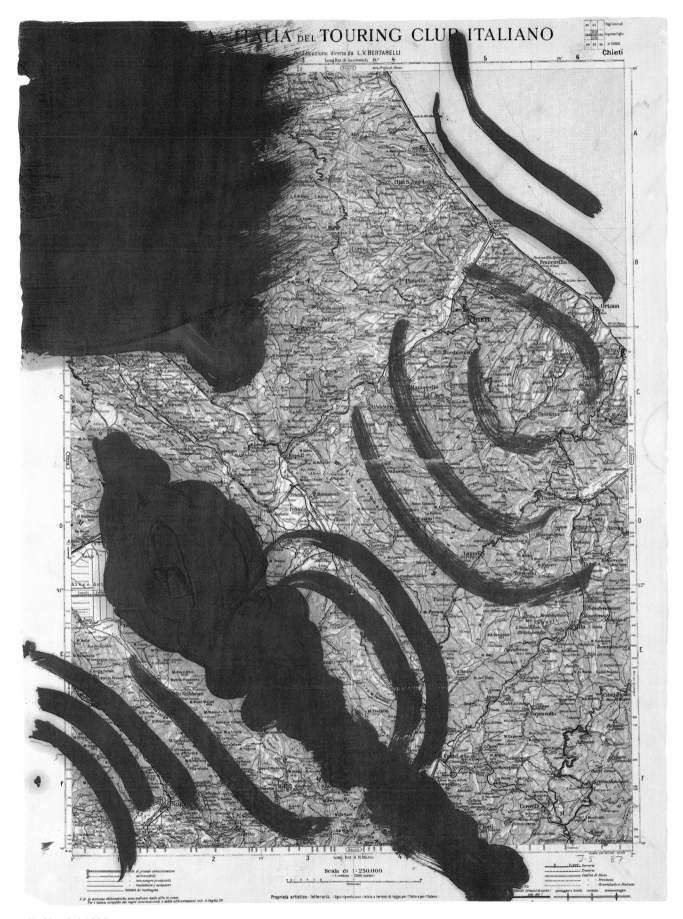

52 *Untitled*, 1987

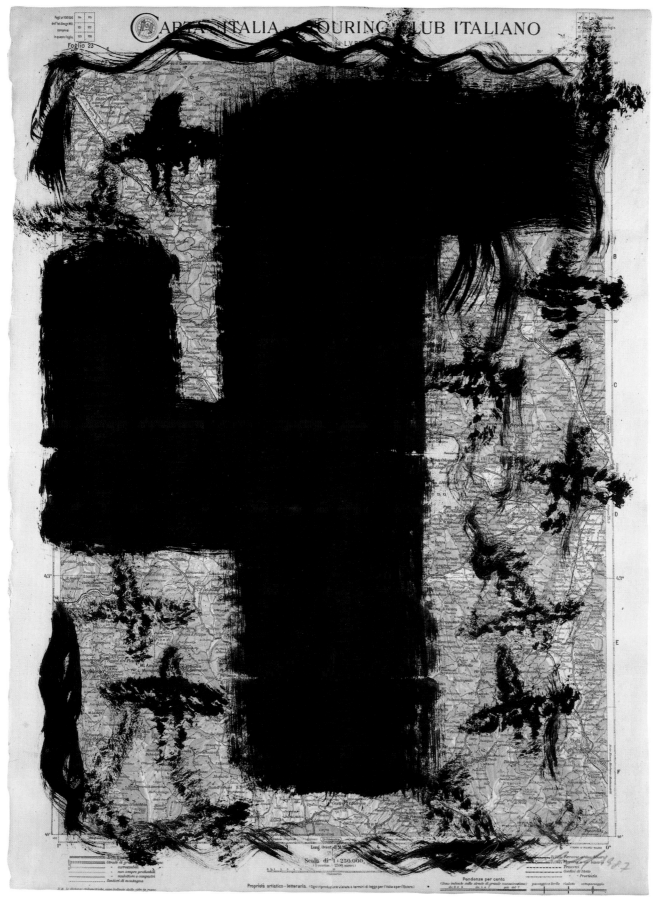

53 *Notes on a Bad Summer*, 1987

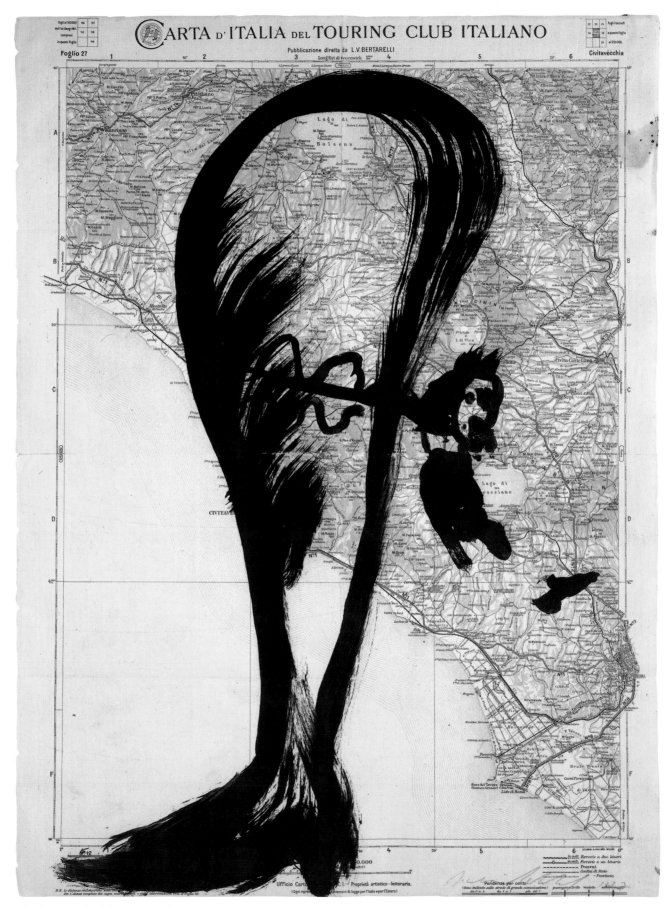

54 *Notes on a Bad Summer*, 1987

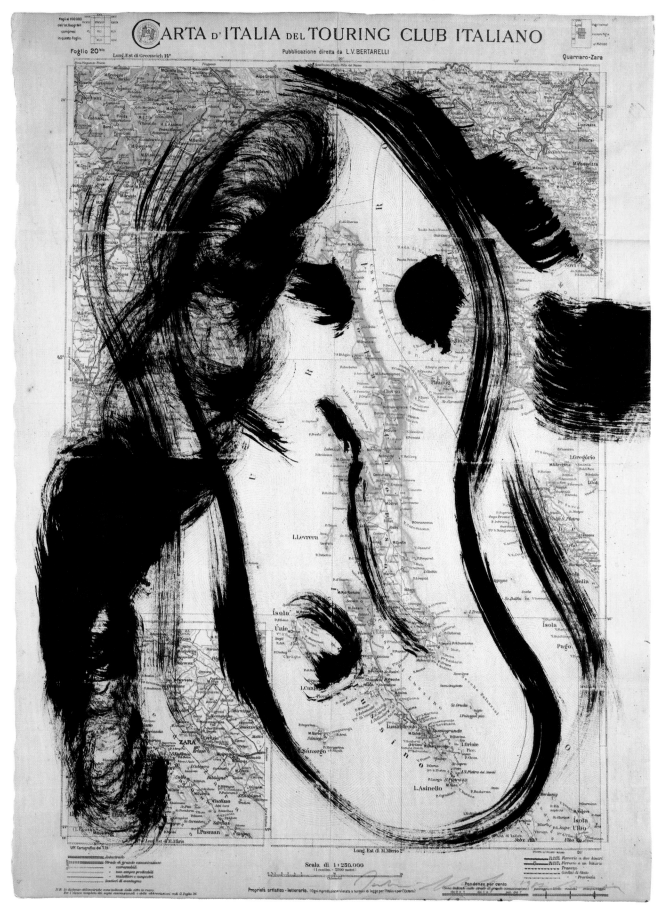

55 *Notes on a Bad Summer (Michel Serrault)*, 1987

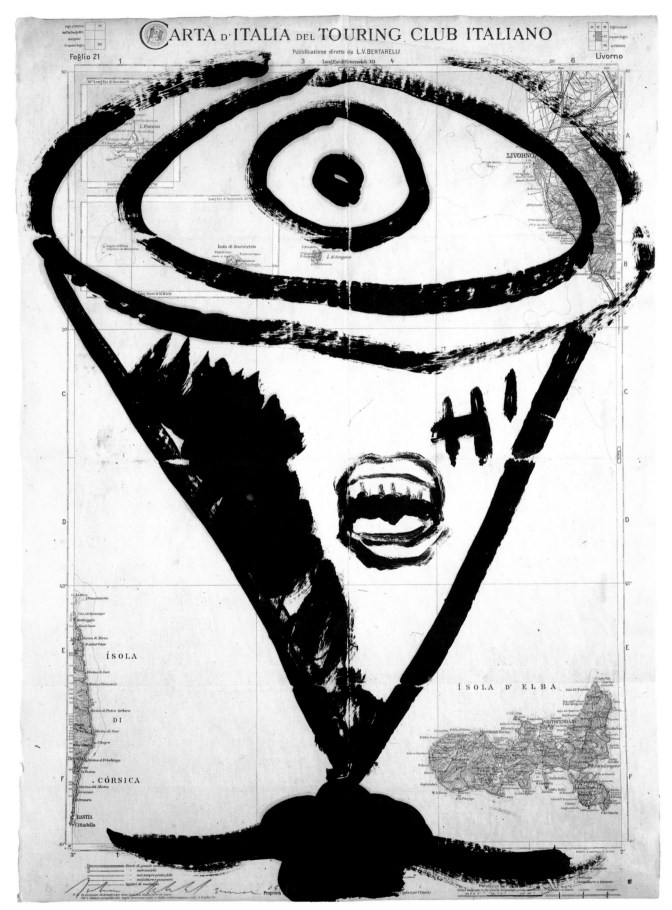

56 *Notes on a Bad Summer*, 1987

57 *Notes on a Bad Summer*, 1987

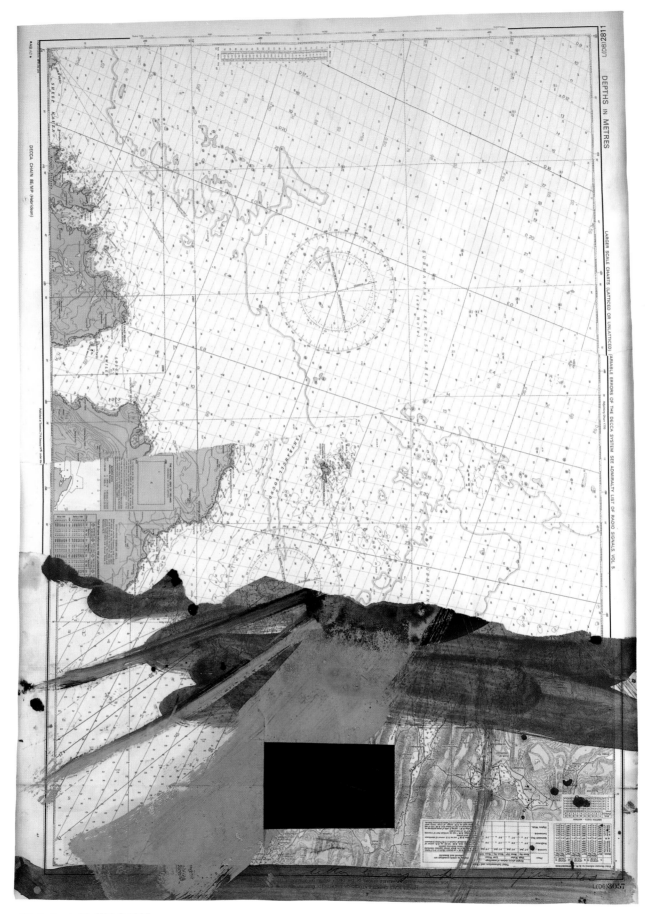

58 *Letter to My Wife I*, 1987

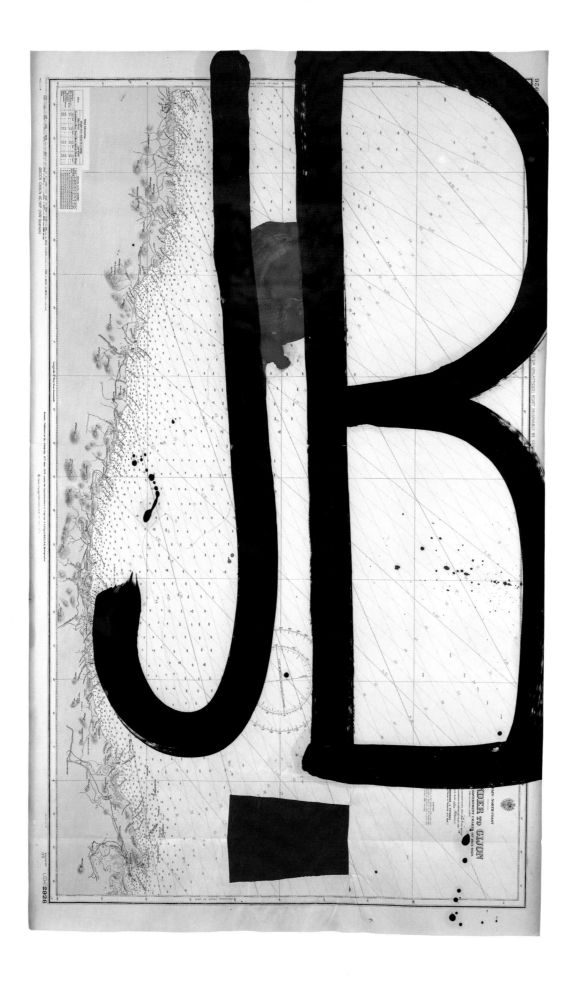

59 *Letter to My Wife II*, 1987

60 *Letter to My Wife III*, 1987

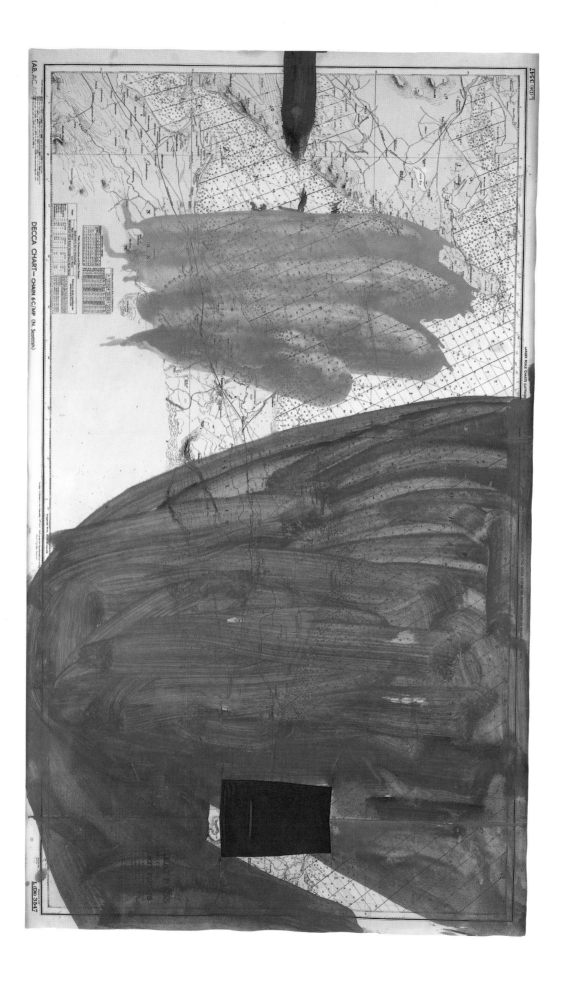

61 *Letter to My Wife IV*, 1987

62 *Letter to My Wife V*, 1987

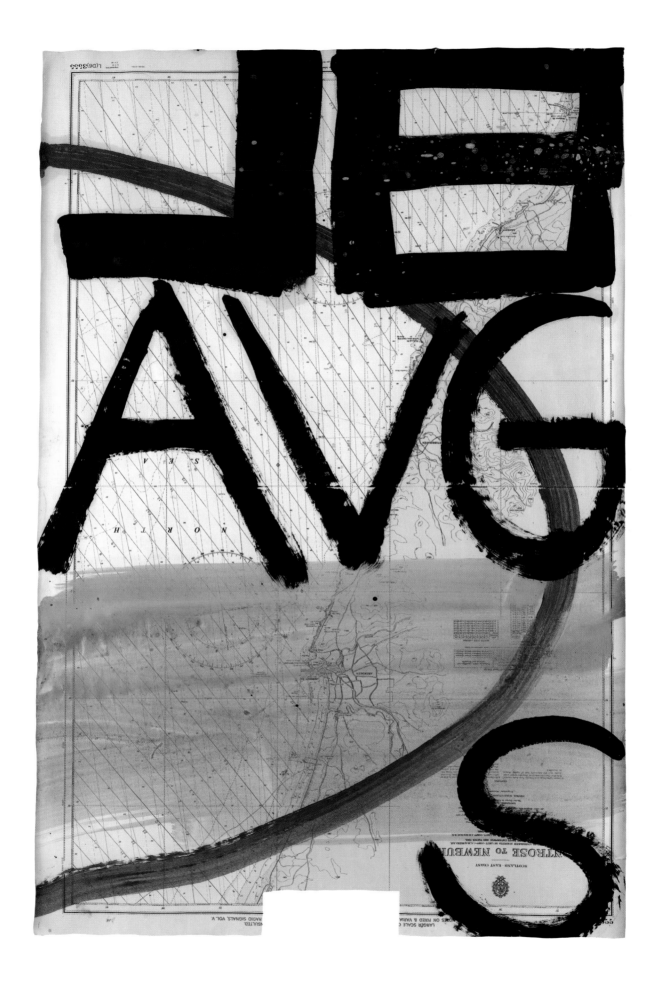

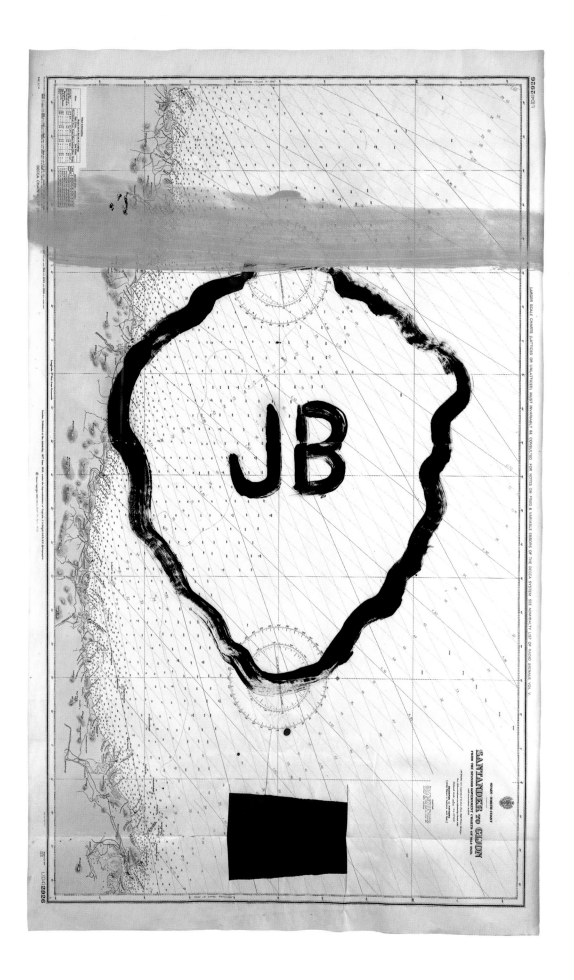

63 *Letter to My Wife VI*, 1987

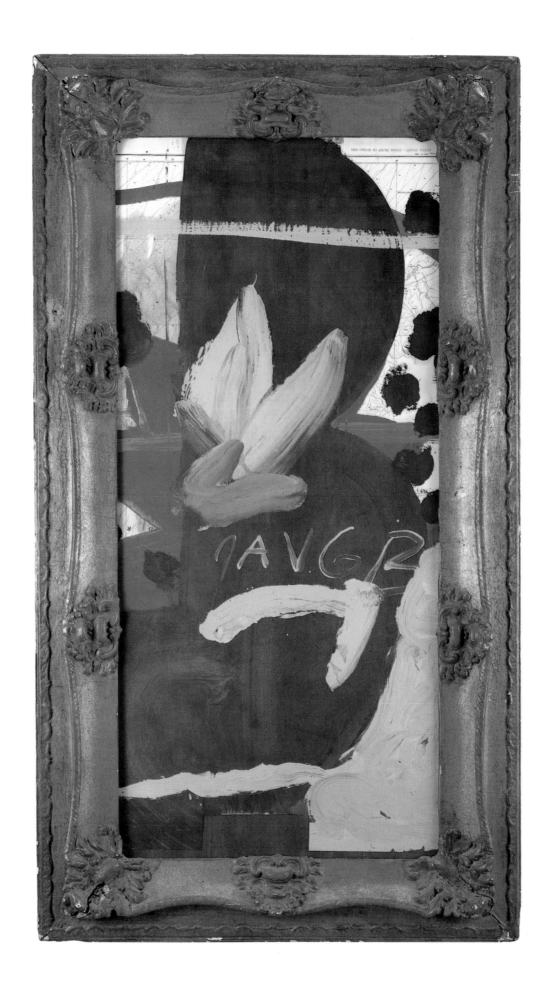

64 *Letter to My Wife VII*, 1987

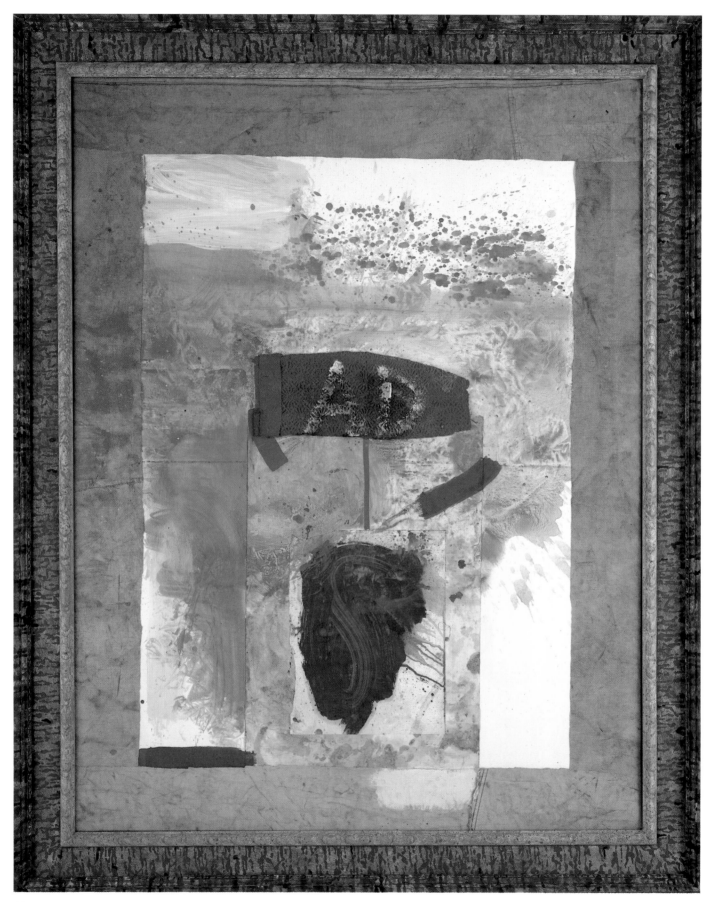

65 *A.D.*, 1987/88

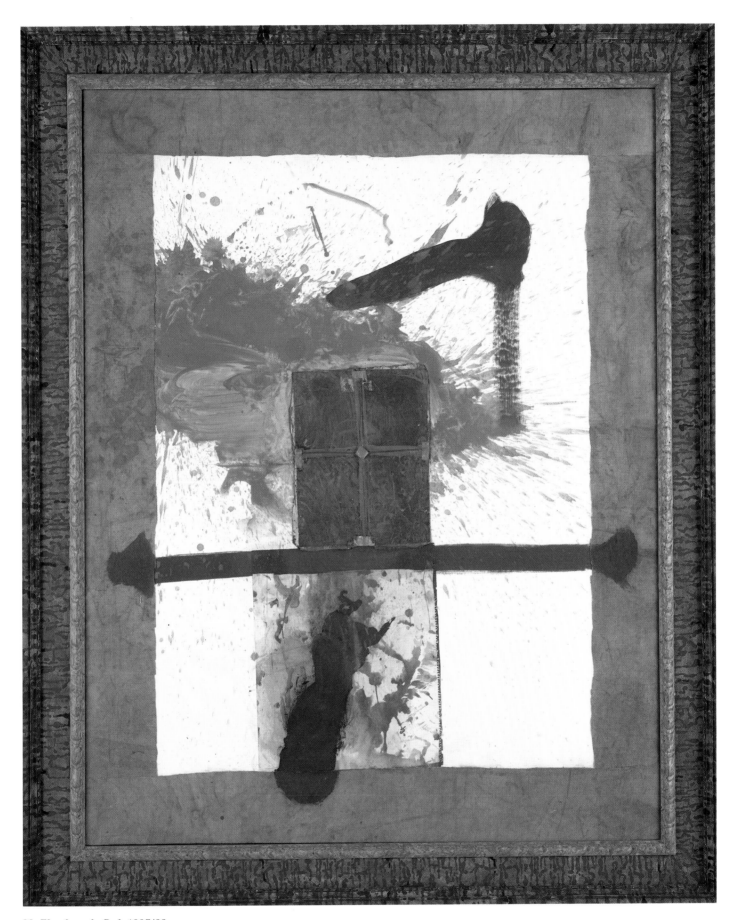

66 *Flag from the Raft*, 1987/88

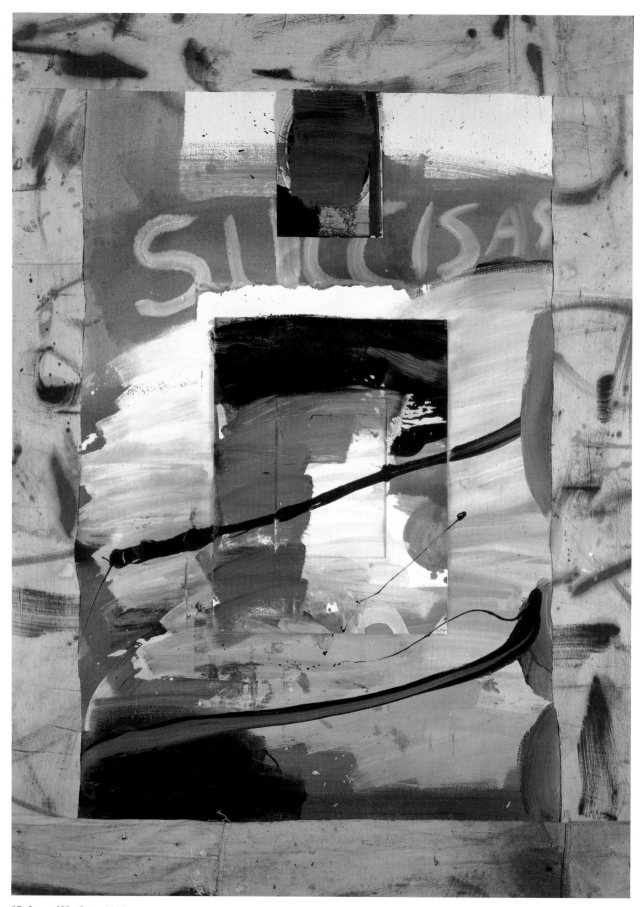

67 *Last of Her Line,* 1988

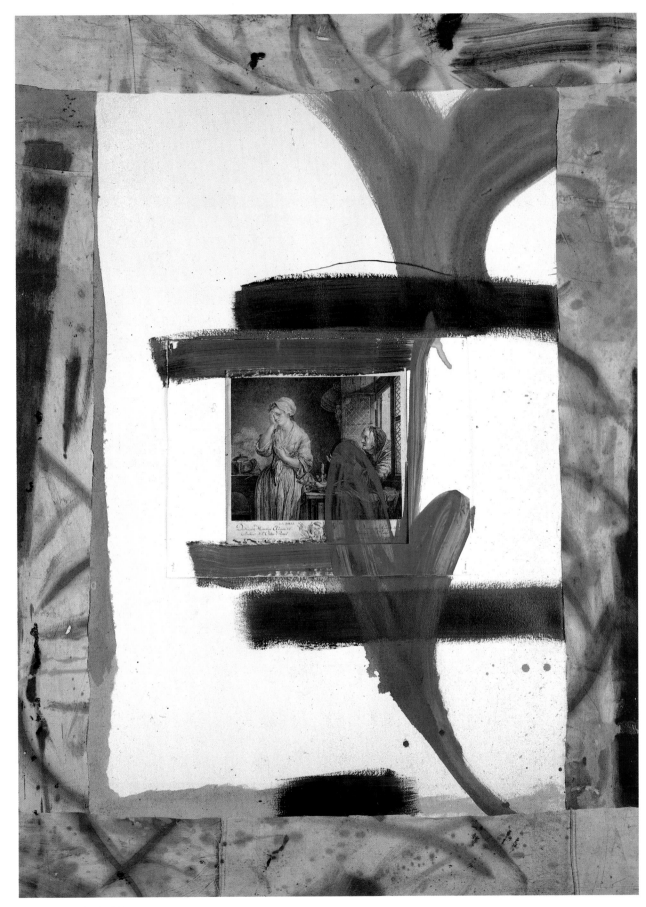

68 *Confused Girl*, 1988

69 *Loss of Innocence*, 1988

70 *Tête d'étude*, 1988

71 *La Banana è Buona*, 1988

Appendix

Lenders to the Exhibition

Douglas Baxter Collection, New York
Steven and Susan Berkowitz Collection, Chicago
Galerie Bruno Bischofberger, Zurich
Ross Bleckner Collection, New York
The Chase Manhattan Bank Collection, New York
George Condo Collection, Paris
Douglas S. Cramer Collection of the Foundation, Los Angeles
Dennis Delrogh Collection, New York
Werner Düggelin Collection, Paris
Liliane Durand-Dessert Collection, Paris
Marcel Fleiss, Galerie 1900 - 2000, Paris
Frederick Hughes Collection, New York
Hank McNeil Collection, Philadelphia
Judith and Edward Neisser Collection, Chicago
The Pace Gallery, New York
Francesco Pellizzi Collection, New York
Alan Powers Collection, Nevada City
REFCO, INC., Chicago
Jacqueline Schnabel Collection, New York
Julian Schnabel Collection, New York
Tony Shafrazi Collection, New York
Mr. and Mrs. Joel Shapiro Collection, New York
Gian Enzo Sperone Collection, Rome
Waddington Galleries, London
Robert Williamson Collection, New York

Catalogue of the Exhibition

Unless otherwise stated, the dimensions given are those of the sheet, not the image, height before width.

1 *Untitled*, 1975
Gouache and pencil on paper, 22¹/₄ x 30 in.
(56 x 76 cm)
Ross Bleckner Collection, New York

2 *Untitled*, 1976/77
Oil and crayon on paper, 28¹/₄ x 40¹/₂ in.
(71.5 x 102.5 cm)
Galerie Bruno Bischofberger, Zurich

3 *Page from Madrid Notebook*, 1978
Ball point pen on paper, 7¹/₄ x 5¹/₈ in.
(18.5 x 13 cm)
Collection of the artist, courtesy of Galerie
Durand-Dessert, Paris

4 *Page from Madrid Notebook*, 1978
Ball point pen on paper, 8¹/₄ x 5 in. (21 x 13 cm)
Collection of the artist, courtesy of Galerie
Durand-Dessert, Paris

5 *Drawing for 'What to Do with a Corner in Madrid'*, 1978
Ball point pen on paper, 8¹/₄ x 5¹/₄ in.
(21 x 13.5 cm)
Galerie Bruno Bischofberger, Zurich

6 *Page from Madrid Notebook*, 1978
Pencil, graphite on paper, 8¹/₂ x 5¹/₂ in.
(21.5 x 14 cm)
Liliane Durand-Dessert Collection, Paris

7 *Page from Madrid Notebook*, 1978
Pencil, graphite on paper, 5⁵/₈ x 3⁵/₈ in.
(41.5 x 9.3 cm)
Collection of the artist, courtesy of Galerie
Durand-Dessert, Paris

8 *Untitled*, 1978
Ball point pen on paper, 8¹/₄ x 5³/₈ in.
(21 x 13.5 cm)
Collection of the artist

9 *Untitled*, 1978
Ball point pen on paper, 8¹/₄ x 5¹/₄ in.
(21 x 13.5 cm)
Collection of the artist

10 *Gesù Deriso*, 1978
Oil and wax en paper, 32 x 40 in. (81.3 x 101.6 cm)
Hank McNeil Collection, Philadelphia

11 *The Rhine, Page from German Notebook*, 1978
Ball point pen on paper, 8¹/₄ x 5¹/₄ in.
(21 x 13.5 cm)
Collection of the artist

12 *Untitled Drawing for Aldo Moro*, 1978
Oil and pencil on paper, 93³/₄ x 30 in. (101 x 76 cm)
Robert Williamson Collection, New York

13 *Joan of Arc*, 1978/79
Oilstick on paper, 39¹/₂ x 55¹/₂ in. (100 x 141 cm)
Robert Williamson Collection, New York

14 *Drawing for Albrecht Dürer*, 1979
Oilstick and pencil on paper, 56 x 39³/₄ in.
(142 x 101 cm)
Dennis Delrogh Collection, New York

15 *Accattone*, 1979
Wax, oilstick and graphite on paper, 45 x 34¹/₄ in.
(114 x 86.8 cm)
Collection of the Douglas S. Cramer Foundation,
Los Angeles

16 *Untitled Drawing*, 1979
Sienna pencil, plaster and joint compound on
paper, 27³/₄ x 39¹/₄ in. (70.5 x 100 cm)
Collection of the artist

17 *Second Drawing for Aldo Moro*, 1979
Oil, graphite and plaster on paper, 36 x 46 in.
(91.4 x 116.8 cm)
Francesco Pellizzi Collection, New York

18 *Untitled*, 1979
Oilstick, pencil and photo-reproduction on paper,
78¹/₂ x 55¹/₂ in. (199.5 x 141 cm)
Galerie Bruno Bischofberger, Zurich

19 *The Conversion of St. Paul*, 1979
Oil, crayon, graphite, and photo-reproduction on
paper, 52¹/₄ x 39¹/₄ in. (133 x 100 cm)
Werner Düggelin Collection, Paris

20 *Arm*, 1979
Oil, pencil and photo-reproduction on paper with
cowhide, 66 x 50¹/₄ in. (167.8 x 127.5 cm) (with
frame) 55¹/₄ x 39¹/₄ in. (140.5 x 100 cm) (without
frame)
Galerie Bruno Bischofberger, Zurich

21 *Untitled*, 1979
Oilstick and pencil on paper with cowhide, 66 x 50
in. (167.5 x 127 cm) (with frame) 55 x 39¹/₄ in.
(140 x 100 cm) without frame)
Robert Williamson Collection, New York

22 *Blinky and Imi*, 1979
Oil, graphite and plaster on paper, 39¹/₄ x 27³/₄ in.
(100 x 70.5 cm)
Galerie Bruno Bischofberger, Zurich

23 *Untitled (Divan)*, 1979
Graphite, painstick and rice paper on paper,
59³/₄ x 40¹/₄ in. (151.5 x 102 cm)
Steven and Susan Berkowitz Collection, Chicago

24 *Untitled*, 1979
Pencil on paper and plaster, 27³/₄ x 39¹/₄ in.
(70.5 x 100 cm)
Tony Shafrazi Collection, New York

25 *Untitled*, 1979
Pencil on paper, 39³/₄ x 30 in. (101 x 56 cm)
Collection of the artist

26 *Memory of a Crucifixion (Part 2)*,
1979/80
Oil and gouache on paper, 69¹/₄ x 61¹/₂ in.
(176 x 156 cm)
Collection of the artist

27 *From the Names of Our Children*, 1980
Contact paper on map, 41¹/₂ x 29 in.
(105 x 73.5 cm)
Judith and Edward Neisser Collection, Chicago

28 *Dead Drawing*, 1980
Pencil and oilstick on paper with cowhide,
50^1/4 x 40 in. (127.5 x 101.5 cm) (with frame)
39^3/39^34 x 29^3/4 in. (101 x 75.5 cm)
Ross Bleckner Collection, New York

29 *Christ Entering Zihuatanejo*, 1980
Ink on blue paper, 60^3/4 x 44^3/4 in.
(154.5 x 113.5 cm)
Mr. and Mrs. Joel Shapiro Collection, New York

30 *Untitled*, 1981
Ink on paper, 49^3/4 x 37^3/4 in. (126.5 x 96 cm)
Galerie Bruno Bischofberger, Zurich

31 *Untitled*, 1981
Ink on paper, 49^3/4 x 38 in. (126 x 96.5 cm)
Galerie Bruno Bischofberger, Zurich

32 *Untitled*, 1981
Ink on paper, 49^3/4 x 38 in. (126 x 96.5 cm)
Galerie Bruno Bischofberger, Zurich

33 *Voltaire*, 1981
Chinese ink on paper, 49^3/4 x 38 in. (126 x 96.5 cm)
Gian Enzo Sperone Collection, Rome

34 *Untitled*, 1981
Oil on paper, 67^1/4 x 47^1/2 in. (171.5 x 120.5 cm)
Mr. and Mrs. Joel Shapiro Collection, New York

35 *Drawing in the Rain, Pomme de Terre*,
1981
Ink on paper, 23 x 28^3/4 in. (58.5 x 73 cm)
Galerie Bruno Bischofberger, Zurich

36 *For a Bunch of Grapes*, 1981
Oil on map and paper, 60^1/4 x 40^1/2 in.
(153 x 102.5 cm)
Private collection, Geneva, courtesy of Yvon Lambert, Paris

37 *Untitled*, 1981
Oil on paper, 70^3/4 x 61 in. (180 x 155 cm)
Marcel Fleiss Galerie 1900-2000, Paris

38 *Drawing for Sculpture*, 1982
Ball point pen on paper, 13^3/4 x 8^1/4 in.
(35 x 20.5 cm)
Collection of the artist

39 *Death of an Ant Near a Powerplant in the
Country*, 1982
Oil on map, 54^3/4 x 37^1/2 in. (139 x 95 cm)
Collection of the artist

40 *View Near Fort Felipe*, 1982
Oil on paper, 38 x 25^1/2 in. (95.5 x 64.5 cm)
Collection of the artist

41 *Rose Garden in the Winter*, 1982
Oil and pencil on paper, 39^1/4 x 28 in. (100 x 71 cm)
Jacqueline Schnabel Collection, New York

42 *Untitled*, 1983
Watercolor on map, 20 x 15 in. (50.5 x 38 cm)
The Chase Manhattan Bank Collection, New York

43 *Untitled*, 1983
Oil on map, 20 x 15 in. (50.5 x 38 cm)
Collection of the artist

44 *Untitled*, 1983
Oil on map, 20 x 15 in. (50.5 x 38 cm)
Collection of the artist

45 *Untitled*, 1983
Oil on map, 20 x 15 in. (50.5 x 38 cm)
Collection of the artist

46a *Source Material for: Glory, Honor,
Privilege and Poverty*, 1983
Oil, pencil and photo-reproduction on paper,
14^3/4 x 10^3/4 in. (37.5 x 27.5 cm)
Galerie Bruno Bischofberger, Zurich

46b *Source Material for: Glory, Honor,
Privilege and Poverty*, 1983
Oil and photo-reproduction on paper, 14^3/4 x 10^3/4
in. (37.5 x 27.5 cm)
Galerie Bruno Bischofberger, Zurich

47 *Die Elbe*, 1985
Oil on map and paper, 69 x 57^3/4 in.
(175 x 146.5 cm)
Collection of the artist

48 *Untitled*, 1986/87
Oil and map on paper, 75 x 58 in. (190.5 x 147 cm)
Gian Enzo Sperone Collection, Rome

49 *Untitled Purple Drawing II*, 1987
Oil on paper, 40^1/4 x 36^1/4 in. (102.5 x 92 cm)
George Condo Collection, Paris, courtesy of
Galerie Bruno Bischofberger, Zurich

50 *Untitled Purple Drawing IV*, 1987
Oil on paper, 40^1/4 x 36^1/4 in. (102.5 x 92 cm)
Collection of the artist

51 *Notes on a Bad Summer*, 1987
Oil on map, 19^7/8 x 15 in. (50.5 x 38 cm)
REFCO, INC., Chicago

52 *Untitled*, 1987
Oil on map, 19^7/8 x 15 in. (50.5 x 38 cm)
Collection of the artist

53 *Notes on a Bad Summer*, 1987
Oil on map, 20 x 15 in. (51 x 38 cm)
REFCO, INC., Chicago

54 *Notes on a Bad Summer*, 1987
Oil on map, 19^7/8 x 15 in. (50.5 x 38 cm)
REFCO, INC., Chicago

55 *Notes on a Bad Summer (Michel Serrault)*,
1987
Oil on map, 19^7/8 x 15 in. (50.5 x 38 cm)
REFCO, INC., Chicago

56 *Notes on a Bad Summer*, 1987
Oil on map, 19^7/8 x 14^3/4 in. (50.5 x 37.5 cm)
REFCO, INC., Chicago

57 *Notes on a Bad Summer*, 1987
Oil on map, 19^7/8 x 15 in. (50.5 x 38 cm)
REFCO, INC., Chicago

58 *Letter to My Wife I*, 1987
Oil on map with velvet, 39 x 28 in. (99 x 71 cm)
Jacqueline Schnabel Collection, New York

59 *Letter to My Wife II*, 1987
Oil on map with velvet, 45^3/4 x 27^3/4 in.
(116 x 70.5 cm)
Jacqueline Schnabel Collection, New York

60 *Letter to My Wife III*, 1987
Oil on map, 40^3/4 x 28 in. (103.5 x 71 cm)
Jacqueline Schnabel Collection, New York

61 *Letter to My Wife IV*, 1987
Oil on map with velvet, 46^3/4 x 28 in.
(118.5 x 71 cm)
Jacqueline Schnabel, Collection, New York

62 *Letter to My Wife, V*, 1987
Oil on map, 40^3/4 x 28 in. (103.5 x 71 cm)
Jacqueline Schnabel Collection, New York

63 *Letter to My Wife VI*, 1987
Oil on map with velvet, 45^3/4 x 27^3/4 in.
(116 x 70.5 cm)
Jacqueline Schnabel Collection, New York

64 *Letter to My Wife VII*, 1987
Oil on map, 41 x 20 in. (104 x 51 cm) (with frame)
Jacqueline Schnabel Collection, New York

65 *A. D.*, 1987/88

Oil on towel, paper and canvas, 73^1/$_2$ x 57^1/$_2$ in. (187 x 146 cm)
The Pace Gallery, New York

66 *Flag from the Raft*, 1987/88

Oil on paper and canvas with wire, 73^1/$_2$ x 57^1/$_2$ in. (187 x 146 cm)
Waddington Galleries, London

67 *Last of Her Line*, 1988

Oil on paper and canvas with etching, 74^1/$_4$ x 54^1/$_4$ in. (188.5 x 138 cm)
The Pace Gallery, New York

68 *Confused Girl*, 1988

Oil on paper and canvas with etching, 74^1/$_4$ x 54^1/$_4$ in. (188.5 x 138 cm)
The Pace Gallery, New York

69 *Loss of Innocence*, 1988

Oil on paper and canvas with etching, 74^1/$_4$ x 54^1/$_4$ in. (188.5 x 138 cm)
The Pace Gallery, New York

70 *Tête d'étude*, 1988

Oil on paper and canvas with etching, 74^1/$_2$ x 54^1/$_4$ in. (189 x 138 cm)
Douglas Baxter Collection, New York

71 *La Banana è Buona*, 1988

Oil on canvas and paper with etching, 74^1/$_4$ x 54^1/$_4$ in. (188.5 x 138 cm)
Frederick Hughes Collection, New York

Numbers 72 - 74 refer to works in the exhibition not illustrated.

72 *L'incontro alla Porta Aurea*, 1978

Graphite and wax on paper, 31 x 39^1/$_4$ in. (78.5 x 99.5 cm) (left)
31 x 80^1/$_2$ in. (78.5 x 204.5 cm) (right)
Francesco Pellizzi Collection, New York

73 *Untitled (Drawing for Paul Muni)*, 1978

Graphite on paper, 35 x 42^1/$_2$ in. (88.9 x 107.9 cm)
Alan Powers Collection, Nevada City

74 *Journey of a Lost Tooth in India*, 1986

Oil on map and paper, 87 x 36 in. (221 x 91 cm)
Galerie Bruno Bischofberger, Zurich

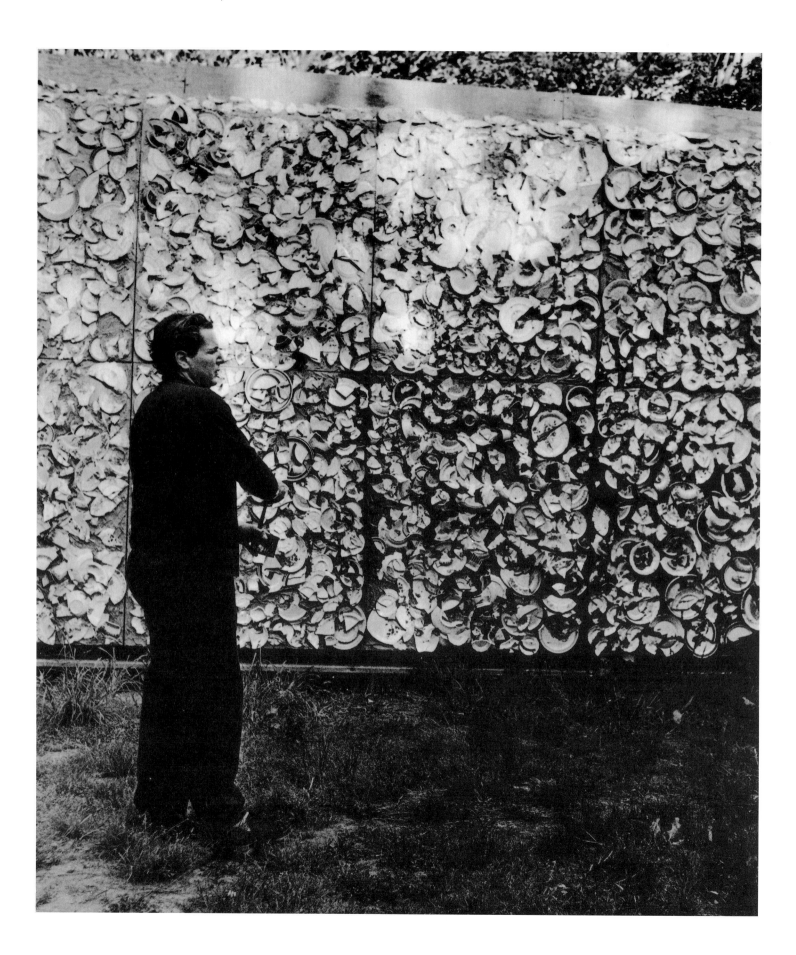

Biography

Julian Schnabel was born in New York in 1951. At the age of fourteen he moved with his family to Brownsville, Texas. He studied at the University of Houston from 1969 to 1973 before returning to New York to attend the Whitney Museum of Art Independent Study Program. After spending eight months in Texas in 1975 and exhibiting his work at the Contemporary Arts Museum, Houston, Schnabel made his first trip to Europe, visiting Paris and Milan, and remaining in Tuscany until April, 1977. The following year he traveled throughout Italy, Germany and Spain, where he was greatly impressed by the architecture of Antonio Gaudí in Barcelona. In February, 1979, Schnabel exhibited for the first time at the Mary Boone Gallery in New York, showing his first "plate-painting" in December of the same year. He has since had solo exhibitions at The Pace Gallery, New York, in 1984, 1986, and 1989. In recent years Schnabel's paintings, drawings, and sculpture have been the subject of numerous traveling exhibitions. The Whitechapel Art Gallery organized a retrospective of paintings dating from 1975 through 1986. Originating in London in the fall of 1986, the exhibition traveled to the Centre Georges Pompidou, Paris, the Städtische Kunsthalle Düsseldorf, and the Whitney Museum of American Art, New York, in 1987; the San Francisco Museum of Modern Art, and the Museum of Fine Arts, Houston in 1988. Also in 1988, the series entitled "The Recognitions Paintings" was exhibited at the Cuartel del Carmen in Seville, Spain. These paintings were then shown at the Kunsthalle Basel in 1989. At the same time the first retrospective of Schnabel's drawings took place at the Museum für Gegenwartskunst, Basel, an exhibition which travelled until summer 1990 to the following museums: the Musée des Beaux-Arts, Nîmes, the Staatliche Graphische Sammlung, Munich, the Palais des Beaux-Arts, Brussels, The Fruitmarket Gallery, Edinburgh, and the Museum of Contemporary Art, Chicago. In 1989 Schnabel has had solo exhibitions at the capc Musee d'Art Contemporain de Bordeaux, and Museo d'Arte Contemporanea, Prato, Italy. Julian Schnabel lives and works in New York and Montauk.

Julian Schnabel at work in Bridgehampton
(Photograph: Alistair Thain)

Selected Bibliography

A complete list of all one man and group exhibitions and of all texts by and on the artist will be found in the following catalogues:

– *Julian Schnabel: Paintings 1975-1986*, Whitechapel Art Gallery, London, 1986.

– *Julian Schnabel: Bilder 1975-1986*, Städtische Kunsthalle, Düsseldorf, 1987.

– *Julian Schnabel, Waddington Galleries, London, 1988.*

– *Julian Schnabel*, Museo d'Arte Contemporane Luigi Pecci, Prato, 1989/90.

Recent publications

– Donald Kuspit, "Julian Schnabel: L'impresario maniériste de l'Apocalypse," in *Artstudio*, 11, Winter 1988, 52-65.

– Brooks Adams, "'I Hate to Think': The New Paintings of Julian Schnabel," in *Parkett*, 18, December 1988, pp. 110-115.

– Thomas McEvilley, "Read this," in *Julian Schnabel: Fox Farm Paintings*, The Pace Gallery, New York, 1989/90, pp. 5-11.

Photographic Credits

Galerie Bischofberger, Zurich 2, 5, 18, 19, 20, 22, 25, 30, 31, 32, 37, 56, p. 8 right
D. James Dee p. 12
Kunstmuseum Basel (Martin Bühler) 1, 8, 9, 11, 12, 14, 16, 23, 38, 52, p. 18 left and right
Grey, Los Angeles 15
The Pace Gallery, New York 17, 42, 43, 44, 45, p. 8 left, pp. 9-11, 13
Beth Phillips 27, 40
Phillips/Schwab 10, 25, 29, 34, 41, 46a, 46b, 47, 49, 50, 53, 54, 55, 57, 58, 59, 60, 61, 62, 63, 64, 65, 66, 67, 68, 69, 70, p. 17
Adam Rzepka, Paris 3, 4, 6, 7, 17
Gian Enzo Sperone Collection, Rome 48
Alistair Thain 110
Sammlung Robert Williamson Collection, New York 21
Zindmann/Fremont 39, p. 14